# THE
# LASCAUX
## CAVE PAINTINGS

### *by Fernand Windels*

The prehistoric wall paintings and engravings in the recently discovered cave of Lascaux, near Montignac in the Dordogne, are now recognized to be among the finest of all the achievements of their kind so far discovered. The state of preservation, artistic quality, number, and the sheer size of the friezes mark them out as one of the greatest and most inspiring spectacles it is possible to behold. The Abbé Breuil, one of the leading experts on this subject, has said that if Altamira is the capital of prehistoric art, Lascaux is its Versailles. Another comparison that has sprung to the mind of those who have visited the great temple-cave is with the Sistine Chapel itself.

This book reproduces in monochrome one hundred and sixty photographs of the cave, together with eight plates in colour. Both photographs and explanatory text have been most skilfully prepared by M. Fernand Windels with the approval of the Abbé Breuil (who writes a foreword) and in collaboration with Mlle Annette Laming. Professor Christopher Hawkes has written a special preface to the English edition and supervised the translation of the text; the following is an extract from his preface.

'At Lascaux there is no mass of excavated data, no classified assemblage of bones and flints. Mind and imagination can help, and do; but what confronts one in this cave, first and last, is the art of its paintings and engravings. Eye and sensibility must meet that and start to take it in, before intellect can reason. So the illustrations are the book's prime wealth; and frankly, I think they are very good. There is no trick photography here, no meretricious enhancements, no flashlit sensationalism. Monsieur Windels worked in the cave with four small acetylene lamps, and no other light at all. I can testify also, having seen direct prints from his negatives, that the reproductions have not let him down. The colour-process work, in the present state of that exactly

[Continued e

THE LASCAUX
CAVE PAINTINGS

FERNAND WINDELS

# THE LASCAUX
# CAVE PAINTINGS

Personal Note by
THE ABBÉ HENRI BREUIL
Membre de l'Institut, Professor at the Collège de France, Paris

Preface by
C. F. C. HAWKES, M.A., P.B.A., F.S.A.
Professor of European Archaeology in the University of Oxford

Introduction by
A. LEROI-GOURHAN
Sub-Director of the Musée de l'Homme, Paris
Maître de Conférences at the University of Lyons

Text prepared in collaboration with
ANNETTE LAMING
Assistant in the Department of Prehistory, Musée de l'Homme, and
Research Assistant in the Centre National de la Recherche Scientifique, Paris

FABER AND FABER LIMITED
24 Russell Square, London

*First published in mcmxlix*
*by Faber and Faber Limited*
*24 Russell Square, London, WC1*
*Printed by the Imprimerie Sapho, Paris*
*and the Shenval Press, Hertford, England*
*from untouched photographs*
*taken with SOM Berthiot lenses*

# Contents

# Table of Illustrations

The plan on pages 56–57 shows where each animal, numbered as below, can be found in the cave. The captions to illustrations throughout the book refer to the animals by these numbers.

2

TO

OUR DISTANT ANCESTORS

WHO WORKED IN THE SILENCE

OF THE CAVES

SOME TWO HUNDRED CENTURIES AGO

IN BELATED HONOUR

OF GENIUS NEVER SURPASSED

Lorsqu'en Octobre-Décembre 1940, Mr F. Windels mit à ma
disposition son grand talent de photographe pour fixer les
admirables fresques de Lascaux, ce fut toute ... du dévouement
qu'il apporta à son œuvre, dans les difficiles circonstances de
l'époque... En 1941, j'eus à Madrid la possibilité d'exprimer
ce que me suggéraient l'exceptionnel complexe artistique de
la nouvelle caverne et les principaux problèmes qu'elle
soulevait. J'y affirmai, d'accord avec ... ...
accueillerons, l'âge périgordien de cet ensemble
pictural, rappelant les blocs peints des réserves ... d'une
vente dans le ... restau à Sergeac par L. Didon
et les ... figures du Portel (Ariège), de F... de gaume, etc.,
qui ... avaient fait soupçonner l'existence
(mais non l'exceptionnelle importance) de cet
... nouveau de l'Art des cavernes, par des témoi-
gnages; j'ai aussi insisté sur l'étroite parenté des cer-
vidés ... et de ceux de l'Art Levantin Espa-
gnol qui, de la Paléolithique, en ... dérivé. J'ai
expliqué le caractère relativement tempéré, de
la faune de Lascaux par comparaison avec
celle, périgordienne avec..., de ... à ...
... chevaux et ..., ... le fait que Lascaux,
inhabitable l'hiver, était, comme le site ...
un site purement estival.

J'avais espéré qu'un jeune artiste, ...

*[handwritten letter in French cursive, largely illegible]*

li devais d'ecrvoir, dès la première heure, comme ... ceux, en publierais, ... me exp ... une description convenable, ... aux ... pustrant ... ; ... tâches, m'empêchent d'y pouvoir voir ... ; le ne ... pas ... l'initiative de M. Windels de ... une corpus photographique des figures de Lascaux ; le déjà en effet ... d'en voir paraître ... dans des magazines étrangers.

M. Windels fut l'un des premiers à ... ; et ... qu'il recueille aux ... sa part ... de l'honneur de cette grand ... , au grand profit du grand public , des artistes et des Préhistoriens

*[signature]*

Dundo (angola). 25.VI.48

See overleaf for translation

# Translation

# of a Personal Note

### by

## THE ABBÉ HENRI BREUIL

*Membre de l'Institut*
*Professor at the Collège de France, Paris*

WHEN, from October to December 1940, Mr Windels put at my disposal his great talent as a photographer to record the splendid paintings of Lascaux, I was struck by the devotion which he brought to his task in the difficult circumstances of that time. In 1941 I had the opportunity of expressing in Madrid what the exceptional artistic content of the new cave had suggested to me, and the main problems which it raised. I affirmed, in agreement with my old friend D. Peyrony, that this ensemble of paintings was of Perigordian age; it recalled the painted blocks discovered by L. Didon in the deposit of that age at Sergeac, and the rare figures at Le Portel (Ariège), at Font de Gaume and elsewhere, which had led me to suspect the existence (though not the exceptional importance) of this new chapter in Palaeolithic cave art; I also insisted on the close relationship of the Lascaux deer with those of the art of Eastern Spain, which has been, since Palaeolithic times, derived from it. I explained the relatively temperate nature of the Lascaux fauna by comparing it with that of the stratum of horses' bones, of the same Perigordian age, at Solutré near Macon, and by the fact that Lascaux, uninhabitable in winter, was necessarily, like Solutré, a summer site.

I had hoped that a young artist, to whom I was indebted for my knowledge of Lascaux from the first moment of its discovery, would publish an adequate description of it during my exile or soon after. The years have passed; my age and my other duties prevent my undertaking it myself; and I can therefore only rejoice at the enterprise of Mr Windels in publishing a photographic corpus of the Lascaux figures. I am tired, I must say, of seeing fragments of them appear in foreign magazines.

Mr Windels was one of the first on the task; it is right that he should now reap his share of the honour of this great discovery, to the great profit of the public, of artists and of prehistorians.

H. BREUIL

*Dundo, Angola.*
*June 25, 1948.*

# Preface

by

## C. F. C. HAWKES

M.A., F.B.A., F.S.A.

*Professor of European Archaeology in the*
*University of Oxford*

THE cave of Lascaux is in the Périgord country of south-west France. It lies high up above the Vézère valley at Montignac; and I went there in 1947, at the beginning of September, with my wife and son. The whole region is famed for relics of prehistoric man, and above all for his cave-paintings; we had seen some the week before, in the great Pech' Merle cave at Cabrerets, and I also at Les Eyzies, the chief French centre for such Palaeolithic studies, in the cave of Font de Gaume. Already in London the Abbé Breuil, professor and Grand Master of those studies, had lectured to us on the paintings of Lascaux; now, our journey to it was arranged by Monsieur Léon Laval, the veteran teacher of the four boys who in 1940 first discovered it; and two of the four, grown tall young men,

went up with us as our guides. We knew it would be wonderful; and we felt prepared.

The improvement-works at the entrance were not then finished, and there was no electric light. We went in, out of the sunshine, to darkness, and to cold, unmoving air. Then quickly the hissing carbide-lamps flashed out, and up at the walls; then we saw what we had prepared for; and it was wonderful indeed, but it left our preparedness far behind. Partly no doubt because, seeing it so, we could feel again something of the discoverers' first amazement; but I think really for more cause than that. We were seeing a vision of another world. Not just an older aspect of our own world, Medieval or Roman or Greek, familiar and friendly; another world, dead not one or two thousand years, but nearer twenty thousand; a world indeed just known, but of a remoteness so immense, that one can all too cheerfully let text-books or museum labels lull one, with that knowledge, into forgetting how

7

much one fails to comprehend. One is not lulled like that at Lascaux. One may, one must, still fail to comprehend; but at least one does not forget how much: I felt, immediately, a stranger and afraid.

Yet the people of that world were men and women somehow ancestral to us; they had invented, in flint, the chisel and penknife of our own tool-bag and waistcoat pocket; we can compare them with tribes still leading lives in some sort like theirs today; they lived by hunting, as men have not ceased to hunt; and to portray their quarry they painted paintings, which are humanity's first known works of art. Contemplate these paintings, now, and the strangeness and fear abate: the world is still another world, utterly sundered by time from the sunshine outside the cave, but once eye and sensibility dare to hover there, mind and imagination can take courage too.

There are, after all, some bare known facts. The Neolithic, the New Stone Age, began in Western Europe perhaps fifty centuries ago; the Mesolithic, the Middle Stone Age that went before it, is more than twice as ancient; and this art is of the Palaeolithic, the Old Stone Age, which ended when that began. When the French call it Quaternary art, as they most often do, they are using the name of its geological period; the closer term for this is Pleistocene, and it is what people loosely call the Ice Age, from its long-continued series of great glaciations. And in the last of them, with its arctic phases divided by warmer but still bleak conditions of open steppe, appeared the men of the 'Upper' Palaeolithic, who were the authors of this art. It was a long stretch of time, and Upper Palaeolithic culture ran in more cycles than one, even in a region the size of south-west France. With the older, named generally Aurignacian, goes the older cycle of painting and engraving; in the middle of it fresh Aurignacians came in, but their predecessors still lived on, and for distinction, can be named here Perigordian. it is to them that the Abbé Breuil would assign the art of Lascaux. Eventually there came changes, with new arrivals distinguished as Solutrian; and then followed the later cycle, when art and the whole hunting culture of this region culminated in a final outcome, with the people we know as Magdalenians.

How that bare mental picture can be filled out, by trained imagination, will be seen often in this book. But at Lascaux there is no mass of excavated data, no classified assemblage of bones and flints. Mind and imagination can help, and do; but what confronts one in this cave, first and last, is the art of its paintings and engravings. Eye and sensibility must meet that and start to take it in, before intellect can reason. So the illustrations are the book's prime wealth; and, frankly, I think they are very good. There is no trick photography here, no meretricious enhancements, no flashlight sensationalism. Monsieur Windels worked in the cave with four small acetylene lamps, and no other light at all. I can testify also, having seen direct prints from his negatives, that the reproductions have not let him down. The colour-process work, in the present state of that exacting craft, can be counted faithful and well done. Infra-red photography, too, used here on a Palaeolithic subject for the first time, has been applied to details with real success.

Over and above all this, Monsieur Windels has written the original text of the book with the expert help of Mademoiselle Annette Laming, of the Musée de l'Homme in Paris, who also holds a research fellowship, as we should call it, at the French National Centre for Scientific Research. Having taken part in its translation into English, I know what I am doing when I praise it. It might have been made an academic thesis, 'proving' this and that about age or attribution, and no more; actually, it is a spontaneous introductory essay, in which scholarship is a background, learning serves not to close questions but to open them, and language is used neither for controversy nor for rhapsody, but—and this goes for Monsieur Leroi-Gourhan's fine Introduction also—simply to quicken and guide appreciation.

Once one has that, there is certainly plenty at Lascaux to discuss. Is the work really Aurignacian? Or, as seems at least equally

possible, is it of the later cycle, Magdalenian? Has it anything, as the Abbé Breuil thinks, to do with the art of Eastern Spain? Or are its affinities all Cantabrian and French? Is the 'scene' in the Shaft really all one composition? Or does the rhinoceros not belong? What is the 'unicorn'? One could go on indefinitely. But the first thing is to take in what Lascaux has to show; and to help one to do that, as far as may be, is the first object of the book.

Yet, of course, it soon brings one to wider matters. Lascaux is what it is, not just for reasons particular to itself, but for major and underlying causes, of broad general import. The animal and symbolic art of primitive peoples, above all of hunting peoples, must have deep significance for the study of man at large. It leads far down towards the roots of what became religious consciousness, and, at the same time, of aesthetic feeling. Primitive art of many kinds is being closely scanned today, when modern art displays so much that can provoke comparison. Art-critics, and aesthetic theorists, will scan it aesthetically, as they must, without blurring their eyes too frequently with questions of magical or religious purpose. Anthropologists, on the other hand, and theor-

ists of psychology, may often scan it as a document for magico-religious attitudes, without paying thorough heed to it as art. Yet Lascaux as a hunters' sanctuary, and Lascaux as a monument of art, are of the same conception; and both kinds of inquirer will gain in common, I think, from this publishing of the material. As a document for a hunting people's 'sympathetic magic' it can scarcely be surpassed; and the chapter here called 'Art and Magic', from this point of view, makes a good commentary both on the animal pictures, and on the more mysterious 'blazons' and other symbols. At the same time, this is the first full photographic treatment for English readers of a major painted cave, whence technique, style, and inspiration can all be studied unreservedly. Trained eyes and sensibilities among us will surely find the study rewarding.

That there is much to engage archaeologists need not be said. They can be trusted not to miss it. But the book's aim is deliberately larger: an invitation. Lascaux is there for everyone.

C. F. C. HAWKES

*Keble College, Oxford.*
*March 1949.*

9

# Introduction

## by

## A. LEROI-GOURHAN

*Sub-Director of the Musée de l'Homme, Paris*
*Maitre de Conférences at the University of Lyons*

WHEN Lascaux was discovered in 1940, very nearly a hundred years had passed since the first prehistoric work of art had been unearthed. During these hundred years thousands of engravings and paintings have revealed this astonishing art, which is separated from the Egyptians by many more centuries than there are between us and the very earliest Dynasties. The study of these works has enthralled specialists, and the Abbé Breuil holds the most eminent place amongst those who have explored the painted caves of France and Spain. He was the first to study Lascaux; and it was he who, from the beginning, inspired Fernand Windels with the wish to fix by photography the features of this unique monument.

Windels' work far surpasses that of a mere photographer; after months of intimacy with the cave he has described it, through his lens, with the same artistic mastery, the same enthusiasm and the same subtlety of scientific analysis, with which another inquirer would have used his pen. Those who are familiar with Palaeolithic painting, however slightly, and those especially who have seen Lascaux, will appreciate what a technique has gone into the photographic rendering of these works, displayed as they are in the most disconcerting situations, and what an effort of scientific exposition has gone to enhance the success of the search for their veritable spirit.

His photographic analysis completed, Windels was helped with the text by Mademoiselle Annette Laming. She, both on the spot and in Paris, undertook a critical analysis of the pictures and sought to determine their position in Quaternary art as a whole. And it was a delicate task, for science is still far from being able to answer all the problems raised by the discovery of Lascaux.

For a long time it has been assumed that Palaeolithic art is a religious art. What is surprising only is that its religious nature should so often have been disputed and held in question: nearly all human art is religious, and for works of art to be splendid does not impair their mystical significance.

Many questions have been asked on the actual meaning of the figures. Totemism, 'sympathetic' magic and cults of fecundity

11

have all been called in to answer them. Such dissections are of little worth, for they seek to explain in the mentality of the twentieth century, or in what we imagine to be the mentality of 'savages', a religious attitude which pertained to men of, very roughly, 25,000 years ago.

Lascaux exhibits most of what are recognized as the signs of Palaeolithic religious sense; animals pierced by darts, pregnant females, and geometrical signs which, for lack of knowledge of their true meaning, are described either as tents, as snares or as blazons. It lacks only the hands, most distinctively symbols of appropriation, which are met with in other caves; and even so, one might imagine that certain signs resembling toothed combs, and perhaps even the blazons, are representations of hands, very much evolved.

When one enters Lascaux, the first impression is of the majesty of a sanctuary, like that which one feels in the painted crypt of a basilica. Nowhere before has Palaeolithic art produced the feeling of composition which rises here from the frieze of giant bulls, and from the herds wandering over the vaults, not at random, but obeying an equilibrium of a sort which disconcerts the mind inured, like ours, to symmetry and perspective.

Another thing is surprising: animals of different ages are painted over one another, regardless of their predecessors, while large spaces remain void around them. This may perhaps be explained by convenience of access; but the execution of the work often implies the use of scaffolding. The cave has thus the appearance of a church where successive re-paintings are all visible through each other. This is a constant phenomenon in prehistoric art; it confounds our present-day conventions, but proves very useful for establishing the sequence of the works in order of time.

The realism of these paintings must not mislead us; the art they display is very highly developed. The Australian aboriginals, though the work they do is much cruder, undergo a regular artistic training—and one thinks inevitably of the technique of the Chinese or

12

Japanese, whom their tradition of brush-work has taught to perfect their sketch first in the mind, and then produce, with a single turn of the wrist, a figure that will never need retouching. That presupposes a very exact codification of lines, which appears clearly throughout cave art. However, there was a certain development in the course of the centuries, in the treatment of eyes, of horns, and of hooves, and it is from these successive conventions that the prehistorian seeks to distinguish the age of the figures.

The age of Lascaux has already been debated. There are a number of repaintings, of animals superimposed in several layers; the style of the little horses is clearly different from that of the large bulls; one feels that the sanctuary was a long time in use, but no clear-cut changing of the styles can be perceived. The matter would be easier to judge if one important point could be settled: did these figures constitute a sort of permanent background made all at once, before which rites were enacted? Or did they accumulate one by one, or in groups, as occasioned by each preparation for the hunt? Or in commemoration of specific exploits? There are in Lascaux reasons for affirmative answers to all three questions. A few small faded figures, half-hidden under the great bovidae, seem to indicate that the large-scale painting at Lascaux was preceded by more modest attempts, and that proportions went on steadily increasing up to the prodigious climax of the bulls over seventeen feet long.

But should this crescendo movement be given a span of several decades, several centuries, or several thousands of years? Everything conspires to make research on this question difficult. There are cases where paintings or engravings occur on dated cave-walls, but they are rare; and, in spite of the Abbé Breuil's masterly systematics, a painted cave is still far from being as easy to interpret as a cathedral.

That idea, that preconception of a prehistoric cathedral, suggests that between the beginning and the ending of Lascaux several centuries may have elapsed. But it would be a mistake to trust impressions drawn from the

condition of the paintings; in the open air light, dust and wear and tear leave a patina which can give one guidance, but in a cave, when stalagmite does not engulf the painting under a crust that is opaque, colours defy time.

Lascaux had several epochs, like our great monuments in which one always finds some traces of archaic work; but its great epoch, that of the bovidae in polychrome and the large horses, is relatively concentrated and homogeneous.

Is it possible to draw conclusions from the animal species which are represented? This book considers the question in detail (p. 109). On the whole the fauna is largely that of a temperate climate—bull, horse, deer, bison, but neither the reindeer nor the mammoth of the Quaternary period's arctic phases; this would place Lascaux either in the Middle phase of the Aurignacian or in the Final Magdalenian. But it is also possible that the fauna is only a summer one. That is, Lascaux may have been visited annually by nomad hunters at the season when horses, bison and deer were ranging northward here while the reindeer had withdrawn for the summer. In that case, Lascaux might be dated between the Upper Aurignacian and the beginnings of the Magdalenian.

We need not suppose, indeed, that the painted caves were frequented all the year round; the example of recent hunting peoples, in particular Eskimos and Indians, shows that favourable hunting grounds determine seasonal migrations, and the fauna depicted in the caves could very well, in many cases, be considered to be seasonal.

There is little reason to suppose that the animals of the Quaternary, identical with those of the north of Eurasia and America, and living in a more or less 'Canadian' climate, should have behaved differently from the reindeer or the bison of America today. South of the reindeer's habitat and north of the bison's, there is a marginal zone frequented seasonally by both, the reindeer and the big bovidae coming in alternately. But, owing to certain differences in their habits, the best hunting-grounds for each are different, and it must have been rare for a hunter to be able to watch the herds from his door-step all the year round.

Can we conjure up, in any more precise fashion, the identity of Lascaux man? He has left behind very little about himself; a few hollow stones which served as saucers for paints and as lamps, a few flaked flints, and the caricature of the man gored to death by the disembowelled bison. This scene (fig. 56) makes one feel that it is perhaps neither pure anecdote nor yet the representation of a disastrous hunt in a sort of tragic pictogram. For a long time yet men will write their comments on this all too simple-seeming scene, and will seek the mysterious link which shall connect the departing rhinoceros, the rows of dots, the stake with the bird on the top, and the central scene—a scene of such naked savagery, that one is almost tempted to see in it a trap for over-ingenious prehistorians.

And what is one to think of the celebrated 'unicorn' (No. 2) at the entrance? This animal is nameless; none of its parts exactly depicts any creature of the period. In the real animals, every line comes from a repertory, and one can often tell from a single foot or horn that it is an ox's or a bison's. But this strange beast, 'unicorn' with two horns, is a consciously created monster: not a composite one like the griffin or the winged bull, but a monster in which every semblance of reality is deliberately violated. The famous sorcerer of Les Trois-Frères is still recognizable; he has identifiable parts; but the Lascaux monster defies analysis, and I do not believe that any zoologist could take the responsibility of correlating those rhinoceros-like or tapir-like hindquarters with anything contemporary in real nature. It almost makes one think of one of those Chinese lions, which hardly have any longer the features of a real lion, but show two men dancing inside a carcase made of stuff.

Looking back from the 'unicorn' to the great animals spread stark over the vaults one sees that everything in prehistoric art is strange. One loses many illusions—that these men were simple primitives; that their art was simple and ingenuous; and the illusion, too, that we, when moved to comment on them, can ever be quite sure of our ground.

13

We can admire the mastery of these hunters as artists; they possessed indeed traditions more ancient than our classical tradition is to us. We can appreciate the religious significance of their thought in the manner of a sensitive but ignorant visitor to an Indian or Chinese temple, who cannot read the symbols, but is aware of the feeling they exhale. We can have a vision of dark naves, a few fat-grease lamps casting tremendous shadows; we can imagine the dramatic potential of the surroundings. Those men were very close to us, physically and mentally, too; the caves have not changed, and whoever is familiar with their depths knows the range of the impressions that meet him there; the crushing stillness of the silence; the instinctive sinking of the voice till it ends by whispering; the sudden burst with which the atmosphere can be transformed by singing, making the decoration flash instantly out in detail as the hold of the dark vaults snaps away; and—then the silence falling once more at the end of the song, more tragic and more bodily than ever.

We cannot think as the hunters of bulls and mammoths thought, but the cave is still the same cave always, with its silence and its echoes. We shall never know why they went down into the bosom of the earth to hide the secret of their hunters' longings; perhaps explanation is too facile. Yet once thought has risen in us, no place could better keep the mystery contained.

A. LEROI-GOURHAN

# Lascaux:
# a Palaeolithic
# Cave-Sanctuary
# re-opened

# Lascaux:

# a Palaeolithic Cave-Sanctuary

# re-opened

ONTIGNAC; a small quiet town on the Vézère. The soft light of the Dordogne country; all around, the stippled crests of the hills. A small town, asleep in the present, which seems always to have been there, with its fields, its vineyards, and its woods.

The cave of Lascaux is a quarter of an hour away from the town, on the edge of a plateau over 300 feet high, dominating the Vézère. It lies within the small estate of Lascaux, the property of the Comtesse de La Rochefoucauld-Montbel, née Darbley, whose mother was a Labrousse de Lascaux, a family which acquired it in the fifteenth century and later built a little château which overlooks the plain. A road, then a path, mounting the steep slope from the valley, lead there. You cross a little wood, and come out on the plateau just at the entrance of the cave. When it was discovered, on September 12, 1940, by four local boys, the entrance was only a narrow slit, opened up twenty years earlier by the fall of a fir-tree.

To slip into it, after a venturesome little dog, was not an easy thing. Now, the Beaux-Arts have undertaken substantial work in opening it up. But then, at the exciting moment of discovery, it was necessary to crawl, without a guide, into a kind of steeply-inclined antechamber, with a feeling of violating, alone, in the silence, the millennial calm of a sanctuary. There were a few yards of rubble, slipping away under one's feet, and to the right a short gallery, damp and bare, which has now been partly stopped up; then, ahead, there opened out the Main Chamber of the cave. It is an oval, 100 feet by 35 and about 20 feet high, with a slight slant carrying on the line of the entrance.

And there, as though filing past in weird games of follow-my-leader, are gigantic oxen, horses and deer. Reds, blacks and yellows, on the fine crystalline 'skin' which gives a varnished appearance to the rock, seem in some places as fresh as though they had been painted twenty years ago. You go on, avoiding the puddles which dot the surface of the ground, and out of the confusion of this extraordinary mass the animals become distinguishable one by one. First of all, on the left appears the first

17

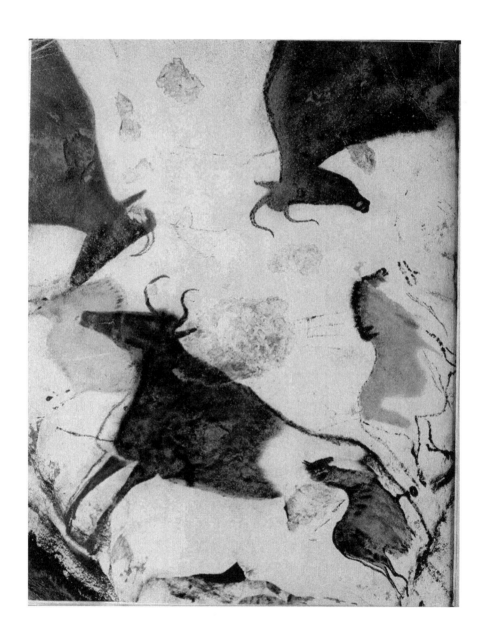

picture of the cave, the black head of a horse (No. 1). * Next comes a fantastic animal (No. 2), of thick-set proportions, with a short snout, a coat dappled with round spots, and a brow which seems to bear two enormous horns; on a lower level several black horses run on round the flat of the wall, along a ledge of rock which surrounds the chamber: the surfaces of this are irregular, and have never been decorated. One of the horses is headless: his head lies on a bit of rock detached from the wall, black and quite recognizable (No. 3).

You then come to two enormous bulls outlined in black (Nos. 9 and 13); they are over 13 feet in length and face one another, making a frame for a set of five little red, black and yellow deer, only three of which are intact (No. 11). Superimposed on the top of the first bull there gallops a large red horse with black mane and hooves (No. 8). Inside the flanks of the second bull is entangled a red cow, in the act of grazing (No. 14). Between the two is silhouetted a remarkable reddish-brown horse, with a black mane but no feet or rump (No. 12). This whole panel is reproduced in colour on pages 76–77.

Farther on there are more horses and two other black bulls (Nos. 15 and 18): the largest and the finest of these measures 16 ft. 6 in. from the tip of the horns to the tail. Between their feet or on their flanks other animals are drawn: some of them are hard to recognize, but among them one can pick out the raised snout of a little brown bear (No. 17). A few sign-spots, blotches, or darts which are some of them stuck on the flanks of the creatures—painted in black or red on the animals or at the side of them—add a note of mystery to this strange group.

The frieze has now passed round the back of the chamber; it continues along the right wall, but soon ends, with a sketch of the head of a fifth black bull (No. 20). With a few more very indistinct traces, it becomes quite impossible to decide whether former paintings have been effaced, or whether the wall has always been left bare.

* The numbers on the plan are also those of the series of illustrations.

Roof of the Axial Passage. Group of bovidae, of slender build (cf. Bos Longyfrons Nos. 23, 24, 44), and the 'Chinese' horses (Nos. 42, 45), surrounded with darts.

Towards the back of the chamber the roof becomes lower and the slope of the ground sharper. You enter a passage, still a few yards high, known as the Axial Passage—which, like the large chamber, is entirely clothed with white exudations of calcite. Just at the entrance a deer with gigantic antlers (No. 46) is painted on the ceiling. And then at once begins an even more effective display than that of the Main Chamber. Amongst several little tawny horses (Nos. 22, 25 and 43), and painted by a remarkable artist, is a group of red cows (Nos. 23, 24 and 44), right on the very pale ceiling. Their delicate silhouettes, their truncated-conical muzzles, and the forward thrust of their horns differentiate them clearly from the great bulls of the preceding chamber. And as at this point the Axial Passage is distinctly narrow, one of the cows straddles right across: its fore feet are on one side, while its tail, continuing the line of its rump, is lost in the base of the rocky wall of the other side, and the whole of its body embraces the arch of the roof (p. 96).

A little farther on towards the right a frieze of small horses (No. 41), very like Shetland ponies, runs the length of the rock, half way up between the floor and the roof, above a cornice which is really the prolongation of the rock ledge of the Main Chamber. They are preceded by two horses of very different build, which have been named the 'Chinese' horses (Nos. 42 and 45), on account of their sagging bellies and short limbs. Above the frieze an enormous cow (No. 40) leaps towards a 'fence' with regular divisions. Farther on still, where the roof of the Axial Passage ends, around two ibexes confronted across another black rectangle with parallel divisions, there is another group of six tawny horses outlined in black (No. 38), still discernible, though in rather a bad state of preservation. The whole of this scene appears on the coloured plate on pages 60 and 61. Signs, spots and blotches are scattered about everywhere, as if at random, amongst the animals.

The opposite wall is less brilliantly decorated, but some of its figures are especially noticeable: a curious red cow (No. 21) with a black head and a disproportionately long tail, a

19

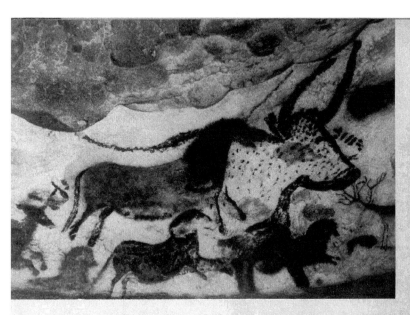

Main Chamber. The horse in the
centre (No. 6: about 9 ft. long) is red,
with black head and legs; he is super-
imposed on one of the gigantic bulls in
black (Bos primigenius: No. 5), under
which can be seen the murals of an
older bull in red. Beneath, two small
tawny-brown horses.

magnificent black bull over 10 feet long (No.
26), two wild asses of which one at least is
pregnant (No. 27), and some other equidae.
Signs, nearly always the same, are seen here
and there. Over a group of tawny-brown horses,
a long line, with branches in darker colour, is
possibly a schematized representation of a plant
—a very unusual occurrence in Quaternary
art.

Towards the end, where the ceiling begins
to get lower, the Axial Passage makes a sudden
turning and a tawny-brown horse appears (No.
51), toppling down into the void with his four

legs in the air. The passage has now become
cramped, and one has to crouch. There is a red
bison (No. 54), a horse (No. 55), and another,
less distinct (No. 52); then one has to creep
along a narrow, twisting tunnel, half blocked
with clay. It is impossible to go more than a
few yards farther: the clay fills three-quarters
of the tunnel and only leaves a few inches of
free space. In any case, it does not seem ever to
have been frequented by the artists of the
principal chambers, and the few stains of
ochre to be seen along the wall are probably
natural.

On getting back to the Main Chamber, still dazzled by this mass of discoveries, you penetrate on the left into a low Lateral Passage, the entrance of which opens out under the paintings on a level with the ledge of rock (Fig. 19 *bis*, p. 40). At first sight the walls of the Passage, of slightly sandy appearance, seem untouched. Only towards the base, on a level where the rock has a crystalline 'skin' identical with that of the Main Chamber, can one see the lower part of two large damaged paintings, of which one shows a curious belly bristling with hair (Nos. 48 and 49). Higher up on the wall there is no trace either of painting or drawing. But a little farther on, by bringing the lamp near to the rock and by controlling the shadows and contriving to get a very slanting light, you can see delicate engravings, with a multitude of fine-meshed lines. Many months would be needed for deciphering all the engravings in this Passage and in the Apse beyond it. This work was begun by the Abbé Breuil at the time of the discovery; it has not been possible to finish it, but recently it has been resumed by Mr S. Blanc, the District Director of Prehistoric Antiquities.

Many of the engravings are merely sketched in, and many have deteriorated; but what makes them particularly difficult to interpret is the fact that they are drawn one on the top of another. After the masterly paintings of the

Nave, left-hand wall, lower register. Two male bison (No. 65), back to back, done in black; that on the left has a broad patch of red on its flank and back. Their horns are shown in absolute perspective, their hooves in twisted perspective. Combined length, about 8 ft.

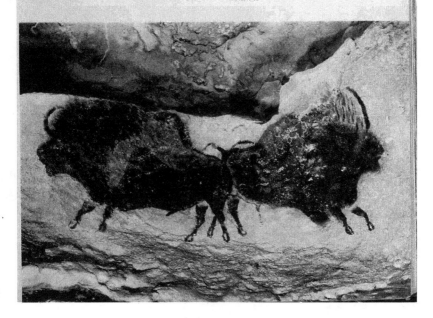

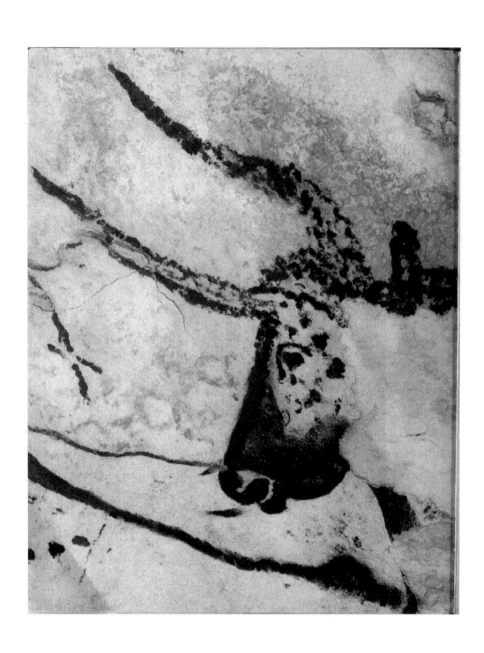

preceding chambers, in fact, we are here confronted with a series of superimposed drawings, a sort of artist's sketch book. Hooves, rumps, tails, heads and antlers are traced in single strokes, clean and precise, without retouching. The dimensions are much smaller than those of the paintings. Many of the engravings are not as much as eight inches across, though others are nearly five feet. They are also often more delicate and graceful, with a greater attention to detail. Most of them seem never to have been painted in, but a few in the passage show traces of red or, more often, brown paint. Amongst them should be noted an amusing little brown wolf, a fairly well-preserved horse and an attractive red ox's head (No. 52).

After a few yards in the Lateral Passage, another chamber is reached, more or less oval and of smaller dimensions, but very high, and with a sloping floor which falls sharply towards the left. This is the Apse. Its walls are blackened nearly all over by ancient paintings, now very indistinct and in some places scraped away, no doubt in order that the many newer silhouettes drawn on them should be more clearly defined. All accessible places on the walls and the ceiling are covered with these sketches, done by an astonishingly sure hand. Amongst the dozens of bulls, bison, horses and oxen two magnificent deer are worth noting (Nos. 54 and 55), as well as a sort of long leafy creeper, softly spreading (No. 53).

The sharp drop of the clayey floor on the left leads straight into what is called the Nave, a high chamber, long, narrow and angular, the walls of which are fairly regularly skirted by a ledge, one and a half to three feet in width. This ledge is horizontal, and though at first not very high, it soon rises to a good many feet in height owing to the fall of the ground. It is on it that one has to concentrate, both on the right and left of the Nave, in order to study the figures.

At the entrance on the left, before the declivity in the floor, a frieze of ibexes with long horns (No. 56 bis) is discernible. It consists of two groups of four animals each, both painted and engraved, partially obliterated, but showing that one group had black heads while the

other had red heads with black horns. The frieze must have had a surprisingly decorative effect. A series of horses next to it is both painted and engraved, as are also most of the animals in this chamber. They are in bad condition. A pregnant mare with her flank pierced by two darts is distinguishable (No. 57), also a stallion pierced by seven darts (No. 59) and a second pregnant mare. The hindquarters of this mare are lightly covered by a dark brown bison, pierced also, by seven arrows (No. 62).

After a short undecorated space, in the middle of a long frieze of little horses (No. 63), in bad condition, there is an enormous black cow (No. 63 bis), evidently pregnant, under whose feet are cut and painted some of the divided rectangles, which Abbé Breuil has provisionally named 'blazons'. These emblems, though of a slightly different type, are clearly akin to those of the Axial Passage. Farther on and under the ledge are two magnificent brown bison, back to back (No. 65).

The wall on the right, which is difficult to get at, has been less worked upon. The long frieze of heads of deer (No. 64), decorating it, is all the more remarkable because it stands alone. Very high up towards the ceiling, in a place difficult to light, five magnificent red deer seem to be swimming across a river. They are done in black strokes, as though with charcoal, and the way they are fashioned recalls the great bulls in the Main Chamber. The whole length of the frieze is over sixteen feet, and the effect is striking.

On beyond the frieze of deer the rock walls close in, and are covered by soft white concretions which can be crushed between the fingers. Neither paintings nor engravings are possible along this passage. From the very high roof ooze drops of water, falling one by one, with a faint sound. The walls are so close that it is difficult to slide through between them. At one place in fact they meet and form a low vault, under which one has to crawl on hands and knees. But soon the ground rises and one is in a kind of steeply ascending tunnel in the rock. It then expands into a sort of little chamber, with abundant engravings on its pale walls. Among them are discernible the sil-

Main Chamber. Detail of the head of bull No. 18 in black. Painted in the 'modelled' technique; the large white patch to the right on the animal's neck is the scar left where a broad flake of the rock has scaled off.

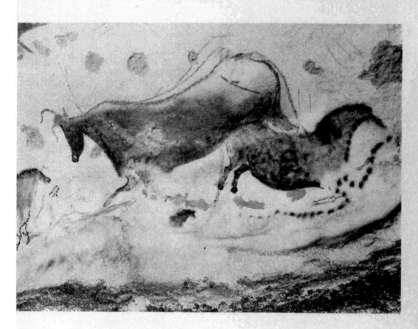

Axial Passage. Cow, No. 44, coloured red. The filling-in is incomplete, leaving the rump to the natural colour of the rock. Length about 6 ft. 6 in. Below, on the right, tawny horse (No. 45), with black mane, legs and belly; under it runs a column line of blotches.

houettes of feline animals, possibly cave lions (No. 66). This chamber is called the Feline Chamber. Then the walls become narrow once more. The climb continues and a second chamber is reached which, though slightly larger, will hardly hold two people. There are many engravings both in the passage and this chamber. Among them one can make out the hindquarters of a bison with lifted tail, several horses, one of them drawn on a half-effaced

black painting, and another, of faded tawny colour with black mane and muzzle, apparently full-face. This place is adorned with a whole series of signs: arrows, crosses, a long waving band made of little brown dashes, and some very delicate blazons like those in the Nave.

The chamber ends abruptly in a precipice, many feet deep. There the rock, much worn, takes the fantastic shape of a gigantic sponge, with protuberances which are easy to grasp in

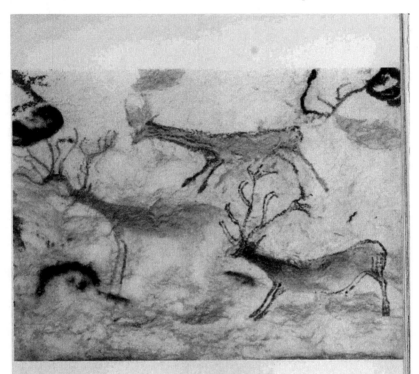

Main Chamber. Detail of the group of small stags, No. 11, each stag about 2 ft. 10 in. long. See the large coloured plate on pp. 76–77; the crooked line above on the right is part of the branch-like object piercing the muzzle of one of the adjoining bulls.

order to get to the other side. On beyond the precipice, with its sheer walls, on which one can see a bison's head, the passage continues like some kind of fissure in the rock, all riddled with holes; it soon contracts into a tunnel half filled with clay; this has not yet been studied, as its clearing out would involve much work. It continues to the right in a narrow vertical slit, nine or ten feet deep, at the bottom of which the water is heard trickling drop by drop. It is not impossible to slip into this fissure, but the walls now show no human traces; and through the clay and rubble which form its end, no way out has yet been found.

On returning on our tracks we find, towards the bottom of the Apse, a natural shaft, formed by the emptying of a pocket of clay between two massive walls of rock, about twenty feet deep. The two rocks under which the Shaft opens are slightly tilted, and must have been

25

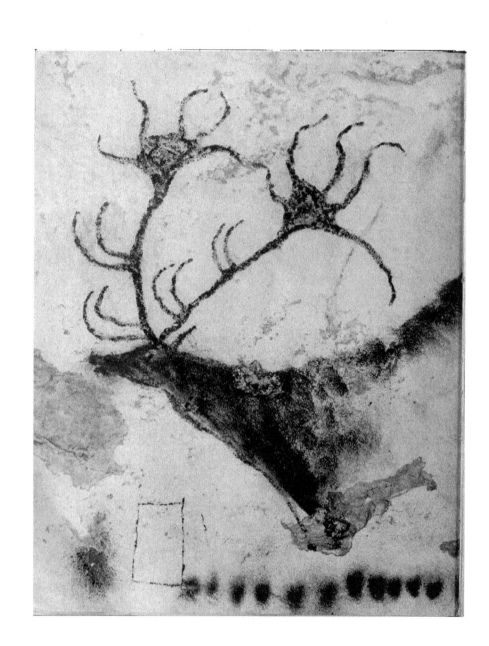

used as holdfasts for the descent, for they are polished and blackened by the passage of uncounted people, beyond doubt many thousand years ago. On their surface are very worn traces of engravings, among which are several small horses and a series of parallel incisions, striating at regular intervals a long raised band of the natural rock.

A ladder or a rope is required for reaching the bottom of the Shaft. There, on the wall facing you when you get down, is painted an extraordinary scene (see page 56). A man, very schematically rendered, with a bird's beak for a face, and sexual organ erect, lies lifeless. Each arm, drawn in a single line slightly thickening towards the top, ends in four fingers. His trunk is simply an elongated rectangle. His feet are only a bent-up prolongation of his legs, which are likewise indicated by two parallel lines, thickening slightly at the thighs and calves. Close to him is a stick, with a hook at one end and a little bar across the other; it is no doubt a spear-thrower. A little lower is a rudimentary bird, with its beak rendered in exactly the same way as the man's face, perched on a stake which seems driven into the ground. Towards the left, and moving away, is a rhinoceros, with two horns, the only one in the whole cave; he is black on a pale background, and his fore-feet are only sketched in. On the right is a bison, drawn in black on a brown background. He menaces, but cannot charge; a spear or assegai has run him through the body; and through the wound, in enormous circles, his entrails are dropping from him. Between the rhinoceros and the man six large black dots, placed two and two, give a final mark of weirdness to this strange Palaeolithic scene. Such compositions where several actors appear are very rare in cave art. Portrayals of human being are very rare also, and so much the more are they impressive.

The clayey walls of the Shaft reveal no other figures, except a dark-coloured horse, badly preserved and indifferently done, and a few traces that are difficult to decipher. And farther one cannot go. To the left, the Shaft is continued by a lofty fissure, which after a few yards becomes too narrow for human entrance, and on the right by a tunnel which is almost entirely blocked by rubble.

We have now visited all the parts of the cave that at present are accessible. To get out, the Apse, the Lateral Passage, the Main Chamber must be crossed again—the ancient beasts, staring quietly down, have lost their secrecy now. A few yards more, and then, suddenly fresh, comes the outside air.

Axial Passage. Head and fore-part of red deer, No. 46, painted in nigger black. Antlers very like those of one of the stags of No. 11 (page 25). Height about 4 ft. 7 in.

# Geology and Chronology

# Geology and Chronology:

# Tertiary Formations and Quaternary

# Paintings

THE valleys of the Vézère and its tributary the Beûne are extraordinarily rich in decorated caves and in rock-shelters. These valleys were hollowed out of the secondary sands and limestones of the Périgord from the middle of the Tertiary era onward, and only acquired their present contour towards the middle of the last glacial period, a few tens of thousands of years ago. At that time the caves and shelters which open out on to the cliffs, often forty or fifty feet up, along ledges difficult of access, had already been occupied for a long time by wild beasts and by man. An easily defensible position, the proximity of water, and a propitious climate have always made them especially favoured dwelling-places.

Neanderthal man was already lodging himself there more than 100,000 years ago. Several hundred centuries later, towards the middle of the last period of glaciation, the man of the Upper Palaeolithic Age, true *Homo Sapiens* this time, came to dwell there and make his wonderful paintings and engravings. Then the climate became warmer. The Magdalenians, the last of the Palaeolithic folk, probably moved off northwards, following the retreat of the reindeer and all the arctic fauna. Men of other cultures came here after them. First, in the Mesolithic Age, there were the Azilians, of whom little is known; later came the Neolithic folk with their pottery, their grain-growing and their stock-raising. Centuries more passed. The caves went on being used during the first metal ages and Roman period, too. Near our own times the men of the Middle Ages built their dwellings solidly against the cave-mouths, and made them impregnable homes of refuge. As witness of their occupation, they left those innumerable rectangular cavities cut in the cliffs, of which the smaller are former beam-holes and the larger ones holes for watchmen. Nowadays the peasants of the Périgord still use the cave-mouths as cow-sheds or for storing fodder.

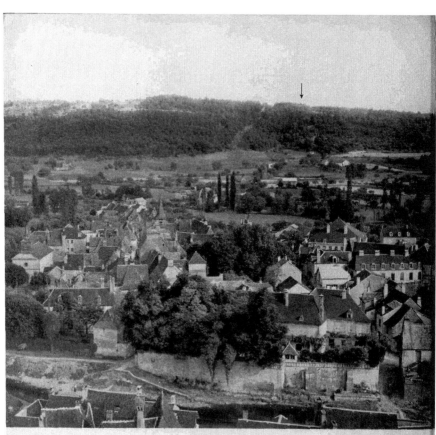

On the top of the ridge, a poplar tree, scarcely visible in the photograph but pointed out by an arrow, marks the exact position of the cave. In the foreground is the Vezere, on its course through the town of Montignac. There are two roads to the cave: one, impassable for vehicles, curves over the ridge on the left; the other, in the distance, leads to the Château of Lascaux, from which, before the cave was opened up, a little path led off through the woods to the high ground.

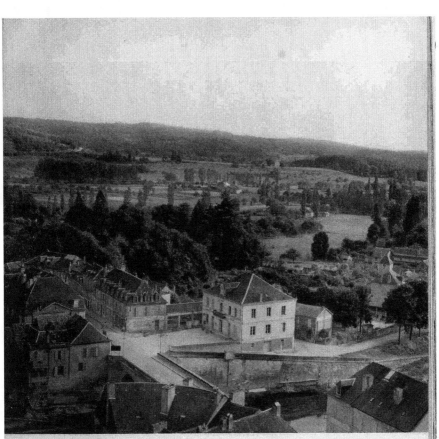

At this point, in the centre at the top of the photograph, a wide roadway has recently been cut to allow vehicles to approach quite near the cave. The road that runs along the side of the Vézère leads to Sergeac (6¾ miles), where the well-known Castanet excavations were made. A main road, on the right of the Vézère (invisible in the photograph) leads to the famous prehistoric site of Le Moustier (7 miles) and to Les Eyzies, the great centre of prehistoric studies (15¾ miles).

The cave of Lascaux, while standing with the rest in the age and mode of its formation, wears rather a different aspect. Its present entrance, in fact, does not open in the cliff but, like a funnel, on the edge of a plateau. Access to it doubtless became possible rather late, and for only a short time, since no traces have been found there either of the great beasts of the glacial fauna, or of any recent occupation.

When Quaternary man took possession of the cave it was in about the same condition as today. Its rediscovery a few years ago, and its subsequent fitting up, have indeed somewhat changed its appearance. When the entrance was enlarged, and a waiting-room for visitors was constructed, every care was taken to preserve as far as possible the natural outline of the plateau, from which no superstructure has been allowed to project. But inside, two very thick walls have been built, barring the end of the first chamber. Their purpose is to isolate as far as possible the atmosphere of the cave and thus to protect the paintings against variation of temperature and of humidity, a problem which, however, has not yet been entirely solved. An invisible drain-pipe collects the seeping waters of the plateau. Nevertheless, the two walls of the entrance once passed, the interior fittings have been carefully devised so as to change the general appearance of the chambers as little as possible. Electric light has been installed, paved pathways made, and the passage leading to the Apse deepened by a central trench; there are a few inconspicuous balustrades; these things, admittedly, may cause a pang to lovers of the picturesque and of local colour.

Serious excavation has not yet been undertaken. Probably, as in most of the decorated caves, it would not yield much material of bone or stone; on the other hand, it might furnish important indications for the dating of the pictures. In any case it would be interesting to carry the spelæological exploration farther, by clearing certain tunnels at present too narrow to admit a human body. Such an undertaking might lead to the discovery of new chambers, and of a way into the lower levels of the cave.

The geological history of the cave of Las-

caux, which the Abbé Breuil has studied, seems fairly simple; from the Tertiary epoch onwards a fissure in the limestone mass of the plateau has become gradually enlarged by infiltrating water, which, in penetrating what is now the entrance, has hollowed out the main cavity and its extensions by dissolution of the limestone. Sands and clays, carried down at different times from the plateau, have given the cave its filling of stratified deposits. This filling, reaching a height of some twenty-five feet in places, is exposed to suction from the inaccessible lower levels of the cave, which explains the sudden changes of floor-level occurring at various places; for example, at the entrance of the Nave. The erosion of the floor by the lower galleries went on after man had abandoned the cave, and it is probable that at the time of its decoration, the filling of the Nave by clay stood at a higher level than now.

The trickling waters of the plateau penetrated at different times into the cave, either through the present entrance, or through fissures, and produced on the floor of the Main Chamber a series of puddles and stalagmitic formations, which are still there, separated by thin layers of gravel and clay. The formation of the present upper floor levels is contemporary with the human occupation, for rare flaked flints are to be found in them.

The roof is made of a limestone of very close grain, harder than that of the walls and of sandy appearance. It is impervious, thus preventing the formation of stalactites, except at one place in the passage before the Feline Chamber where it is thinner and perforated, and where a thick mass of calcite has been formed, which has now rotted to 'mond-milch', and can be crushed by the hand. On the other hand a crystalline exudation from the rock has entirely covered the walls and ceiling of the Main Chamber and of its Axial Passage.

This exudation, depositing itself in the form of small white beady efflorescences, made an ideal background for the paintings, which it firmly fixed. At the time of the occupation of the cave it had already almost ceased in the Main Chamber. It went on longer at the end of the Axial Passage, where in places it per-

54

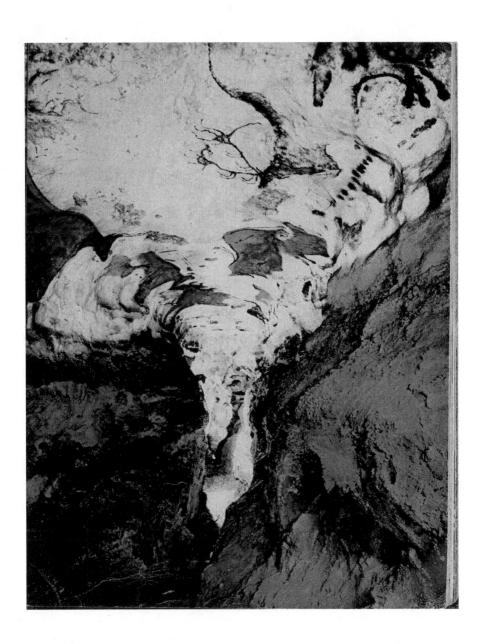

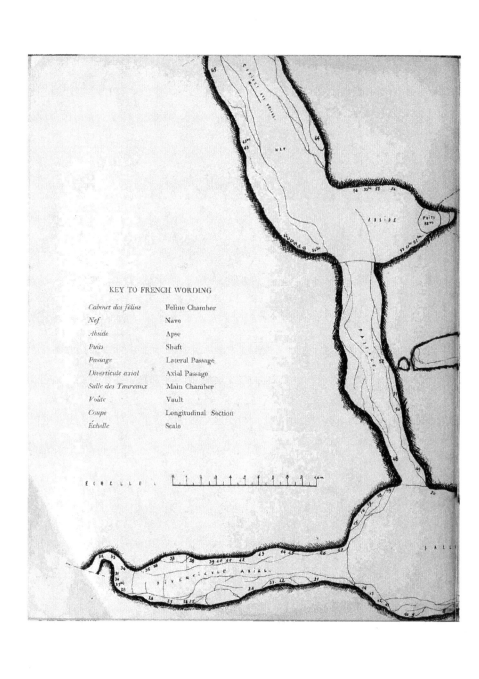

## KEY TO FRENCH WORDING

| | |
|---|---|
| *Cabinet des félins* | Feline Chamber |
| *Nef* | Nave |
| *Abside* | Apse |
| *Puits* | Shaft |
| *Passage* | Lateral Passage |
| *Diverticule axial* | Axial Passage |
| *Salle des Taureaux* | Main Chamber |
| *Voûte* | Vault |
| *Coupe* | Longitudinal Section |
| *Échelle* | Scale |

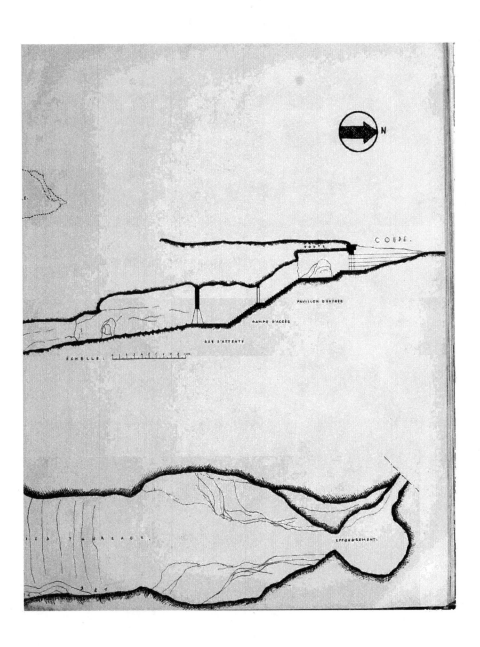

COUPE.

VOÛTE

PAVILLON D'ENTRÉE

RAMPE D'ACCÈS

SAS D'ATTENTE

ÉCHELLE :

EFFONDREMENT.

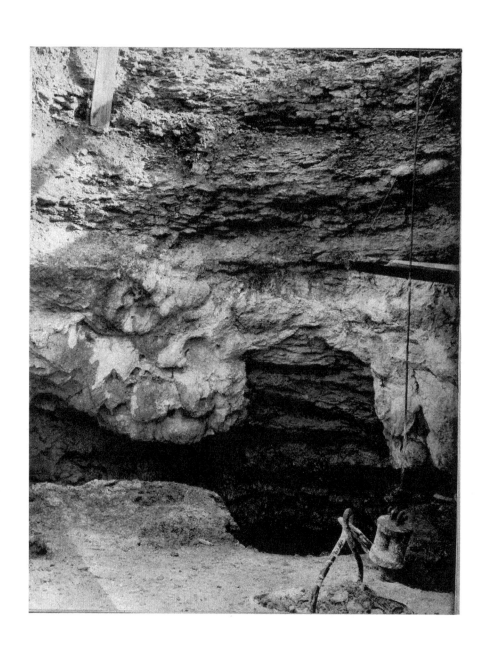

meated the paintings, marking them with little white flakes. This phenomenon is particularly noticeable on horse No. 28.

As a result no doubt of severe frosts, several large pieces of rock have been detached from the wall in the Main Chamber. This happened after the exudation had stopped, because the rock is bare at the places left hollow by the fallen blocks, and also after the execution of most of the paintings, several of which are completely mutilated in consequence (No. 3, No. 18, etc.). The process is still going on, and a block ready to fall can be noticed above the bull No. 18. On certain blocks, still lying on the ground after their fall, the missing parts of the figures on the wall can easily be found, e.g. No. 3.

These phenomena of exudation from and scaling of the walls would alone establish quite certainly the authenticity of Lascaux, if that were necessary. The state of preservation of a great number of the works may indeed appear surprising to those who know how difficult it sometimes is to 'see' the paintings of decorated Palaeolithic caves. As a matter of fact the question of authenticity does not arise at all. The style and general appearance of Lascaux are perfectly in keeping with what we know of Quaternary art. The circumstances of the discovery are known and clear. On the following day, or the day after, the place was visited by Monsieur Laval, the retired schoolmaster of Montignac. No fraud of any extent is possible in that interval. A few days later, on the 21st of September, Lascaux was visited by the eminent Abbé Breuil, who then worked there for several weeks, constituting by his mere presence a perfect guarantee of authenticity.

Authenticity, then, can be admitted without reserve. It remains to be shown how these paintings and engravings have been preserved almost intact through so many thousands of years, while other caves of the same epoch and the same region, such as Font de Gaume and Les Combarelles, have suffered much more. There are several reasons for this. The occupation of the cave coincided, very luckily, with the ending of the calcite exudation process. The paintings thus had the benefit,

in the Main Chamber and its Axial Passage, of a crystalline fixative, which simply encrusted and consolidated them, without going on to obliterate them. This is the contrary of the case in most caves. And the important part played by the calcite in preserving these paintings is shown by comparison with those done directly on to limestone rock. The calcite forms a very solid varnished crust, which time has not impaired. But the limestone rock, in the course of millennia, has gradually become pulverized, dimming the lines of the engraving and carrying away the fine particles of pigment from the paintings. This can be seen on the walls of the Nave (No. 57), and is especially evident in the Lateral Passage between the Main Chamber and the Apse. At the entrance of this, only the lower part of the walls is covered by the calcite exudation: the rock above, which has a sandy appearance, is bare. And it is only at the level of the layer of calcite that the paintings have been preserved; on the upper level (Nos. 48 and 49), they have completely disappeared. An instance of calcification is also to be seen on the clayey walls of the bottom of the Shaft. The scene of the dead man, the bison and the rhinoceros is painted partly on a thin layer of clay left attached to the rock after the hollowing out of the cavity. This clay is encrusted with limestone and has thus formed a relatively solid layer. Knowing the extreme fragility of pictures done on soft clay, one can see how important this phenomenon has been.

The nature of the walls is perhaps not sufficient, however, to explain the extraordinary preservation of the Lascaux pictures. The Abbé Breuil has adduced a further reason, which depends on the position of the cave relative to the plateau. 'It is known that the main cause of the destruction of the walls of painted and engraved caves' he writes 'is attack and dissolution by the condensation-dew of warm summer air, which penetrates them deeply. This cause of destruction does not operate at Lascaux on account of the steep descent at the entrance, which resembles the entrance of a cellar. Warm summer air, being always lighter than cold air, does not get in. There is, therefore, no summer condensation at Lascaux.

59

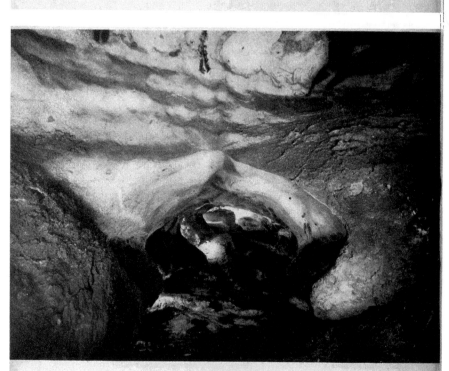

Entrance to the Lateral Passage, with its engravings, leading
to the Apse and the Nave. At the top of the photograph,
feet of oxen belonging to the paintings in the Main Chamber.
A shelf of rock, 3 feet high, surrounds this Chamber, isolating
the paintings from the condensation zone.

Cold winter air, on the contrary, does get in; the air in the cave, then, being relatively warmer, can be seen coming up outside, and forming a column of mist. The cold air covers the floor of the first chamber, and infiltrates gradually to the floor of the rest of the cave, even to the point of freezing there. Then, in the lower levels of the cave atmosphere, occurs the condensation which has decomposed the stalagmite on the floor and the "mond-milch" deposits in the passage beyond the Nave. But at that level there are no paintings; in fact, at every season of the year, the great paintings of the cave remain above the condensation-level. This phenomenon of frost, on the other hand, has detached some pieces of rock from the wall.'

Moreover finally, if access to the cave has been prevented, except for a short time, by the blocking of the entrance with rubble from the plateau, this fact will certainly have contributed much to the preservation of the decorated walls.

In the course of the preceding pages, we have several times already spoken of the age of Lascaux. It may be useful to detail how, actually, it is possible to date such work.

The Palaeolithic Age is divided into several epochs, of unequal length; the Lower Palaeolithic (with Abbevillian and Acheulian cultures), the Middle Palaeolithic (with Mousterian cultures, and remains of Neanderthal man), and the Upper Palaeolithic (with Aurignacian, Solutrian and Magdalenian cultures). The first manifestations of art are not found until the beginning of the Aurignacian; their appearance in our district coincides, broadly speaking, with that of the first known remains of *Homo Sapiens*. The Upper Palaeolithic comes at the end of the glacial epoch and includes the phase of the final retreat of the glaciers. Its duration is relatively short; estimates vary, but include figures of, for example, from 8 to 55 thousand years.

The Upper Palaeolithic, starting in a period of intense cold, soon begins to show signs of a gradual warming, which reaches a climax at the end of the Aurignacian. This climax is followed by a renewed fall of temperature,

Lateral Passage. Legs and belly of a horse (No. 48) painted in black on the 'skin' of calcite which stands out in dark tone on the photograph. The rest of the painting, done on the bare rock showing pale above, has perished. Length about 7 ft. 2 in.

Lateral Passage. Hind leg, belly-line and tail of a dark brown ox (No. 49), surviving because done on calcite; the rest, on bare rock, has gone (cf. No. 48). Length about 6 ft. 2 in. Below: horse No. 1 (length about 4 ft.)

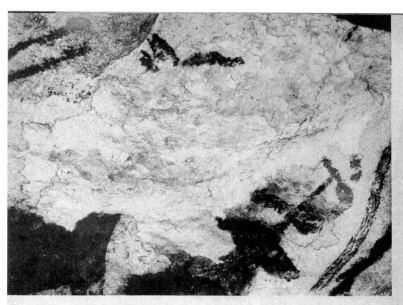

Main Chamber. Example of the destruction of a painting (cf. No. 18, p. 23) by the scaling-off of a large flake of rock, leaving only the muzzle and one portions of the bull's head formerly in the centre, and a headless body on the left below—see new opposite.

which affects the Solutrian and the beginning of the Magdalenian. Then begins a second phase of warming, which continues, through sundry stages, into historic times. The fauna, following these climatic variations, changes from a glacial or arctic character with mammoth and cave bear, to what may be broadly termed a steppe fauna, and then, as vegetation gradually develops, to a forest fauna like the wild fauna of historic times.

The men of the Upper Palaeolithic inhabited caves or rock shelters; in winter, at any rate, the climate was too cold to allow of their inhabiting huts made of branches. They were essentially hunters and fishers. They knew nothing of stock-raising or agriculture.

They plied an industry of stone, of bone and of wood; and, between neighbouring groups, a rudimentary commerce was already practised.

For all questions of chronology the prehistorian has one essential method: stratigraphy. Archaeological strata found superimposed can be assigned a relative age, as a more recent layer is normally found above an older one. Moreover, the association of a given type of tool or bone, in a known geological context, with a definite fauna (warm, cold, or transitional) permits the placing of a prehistoric industry within this or that glacial or interglacial period with a sufficient degree of accuracy.

However, these methods alone cannot decide the age of rock paintings and engravings.

Recourse must be had to other means. Sometimes it happens that the entrance to a decorated cave is covered by a stratum which is archaeologically datable and not disturbed. If the cave has no other exit, it can be taken for granted that the paintings inside are contemporary, at latest, with the latest layers blocking up the entrance. (They can as well, of course, be earlier than these.) Sometimes, again, the base of a painting or of an engraved cave-wall is more or less buried in a layer of deposit which can be dated. In this case also the works may be either contemporary with the layer, or earlier. But these conditions are fulfilled rarely, and they obtain nowhere at Lascaux.

Fortunately other means of dating exist, which are applicable to all Palaeolithic decorated caves. The chief method, and the only one that can give reliable indications, is based on the affinities between mural works of art and works executed on portable objects, carved in bone or ivory, found in strata containing recognized industries; it is completed by study of the superposition of the paintings and engravings themselves, when these are found one upon another. Other methods, less exact and used mainly for confirmation and checking, are based on study of the fauna and the industry that may be represented.

Excavations have brought to light a number of carvings and engravings on bone, ivory or stone. These portable works of art can easily be dated by their association with an industry. Their styles vary from one layer to another on the same site, but are found from one site to

The flake of rock sealed off the wall photographed opposite, lying fallen on the floor, shewing the middle portion of the bull's head, and the horse's head (No. 5) belonging to the body on the left. These have since almost wholly vanished.

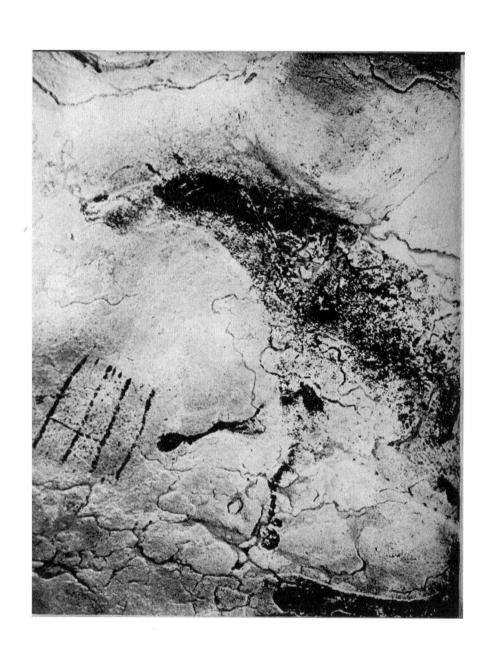

another in the same succession. Thus they do not represent the individual fancies of one or more artists, but characterize very definite periods in the evolution of an art, exactly as various schools of modern painting are each characteristic of a given period. Moreover, these styles recall, and are even identical with, the different styles of mural painting and engraving; and it is possible, in theory, to date a rock painting by comparison with a bone carving of the same style. In practice, admittedly, things are not so simple, and this method of dating is an exceedingly delicate business.

The Abbé Breuil, by fundamental research conducted on these lines, has arrived at a relative chronology for Quaternary art. In this, the evolution of the art is divided into two chief cycles, the first Aurignacian, the second Magdalenian. It is by reference to this comprehensive system that the Abbé Breuil has been able to propound a dating for the Lascaux works of art. In his report to the Academy of Inscription and Belles Lettres on October 11, 1940, he states that in his opinion they find their undoubted place in the last phase of the Aurignacian, that is, at the end of the first period of the 'reindeer' age. In the last chapter we shall revert to these conclusions, in their main lines, and consider briefly the criticisms which can be made of them. Whether this dating of Breuil's is accepted for Lascaux or not, careful study of the superimpositions of the paintings and engravings makes it possible to establish at least a relative chronology of styles. Such a chronology cannot enable us to determine whether two distinct periods or styles are separated by decades, by centuries, or by millennia; but it does enable us to say that such and such a style is later than, or earlier than, another.

Once the succession of styles has been determined, we can look to see whether or not each of them carries the representation of a different fauna. If so, then the lapse of time between two given distinctive styles will have been long enough for the fauna, the centre of the artist's interest, to change. However, in the case of Lascaux this study does not lead to any clear conclusion, for the non-distinctive species, i.e. those like the horse and bison that turn up repeatedly in all post-glacial faunas, are represented in all the styles, while distinctive species, such as the mammoth and reindeer, are represented either not at all, or, like the rhinoceros, only once.

The study of the signs or emblems represented, especially of the blazons, leads to one interesting observation. These rectangles, divided vertically by two parallel strokes and horizontally by a stroke a third of the way up, keep their essential characteristics in every case, whether they are found in the Axial Passage, in the Nave, or in the passage beyond the Feline Chamber, whether they are outlined in black or brown, or engraved and painted in various colours, or merely engraved. In particular, one or two small black vertical strokes cut in the top of the central part are found in most of the examples. Whatever the meaning of it may be, the constant recurrence of this sign shows that in all cases the intention has been to represent the same symbol or object. An emblem so precise can only belong to a single culture. This goes to show that the development of the greater part of the styles at Lascaux occurred within a relatively short time.

Finally, it is worth remembering that, although no serious excavation has yet been undertaken at Lascaux, several small flint tools have been found, either on the surface of the ground, or under scarcely a fraction of an inch of clay. They are flakes; including definite blades, but more often quite small chips. Some have trimmed edges, but most of them are broken. None shows a really typical form and they can scarcely be classified as a whole. However, the general absence of finish, and the very small size of the majority of the pieces, do rather suggest a Magdalenian industry. This, of course, would conflict with the conclusions mentioned above; but the indications it is based on are too slight for it to be given any positive importance.

45

# Art and
# Magic

# Art and Magic:

# Decorative Composition and

# Ritual Intent

OPINION is nowadays unanimous that the decorated caves of the Quaternary period, such as Lascaux, can be nothing else but Palaeolithic sanctuaries. The theory that they were cave dwellings is ruled out by the very conditions which obtain in most of them. Though the Lascaux cave is spacious and relatively dry, we have seen that the position of some of the chambers below the entrance makes it extremely cold in winter. And nevertheless, if this theory were credible, it would rank as a better cave to dwell in than most others. How can one imagine people dwelling in the Combarelles cave for instance, which is just 220 yards of narrow tunnel? Or at Niaux, where the pictures only start 520 yards inside the entrance? Excavations made in these different caves have always yielded roughly the same result. There has been habitation, sometimes, at their entrances; these have yielded flint or bone tools, ivory or reindeer-antler carvings, and cooking-refuse of mixed bones, thick beds of ash, and traces of wood-charcoal. Within, nothing has been found below the floor-surface. The rare finds there consist of flint tools, including graving tools or burins used doubtless for engraving on the cave-walls; and curiously enough, some are particularly fine pieces.

The paintings and engravings themselves, too, bespeak serious intention; there can be no question of mere pastime, or individual fancy. They have a clearly-determined area of geographic distribution from the Charente to the Cantabrian mountains, and from the Atlantic to the Alps; throughout it, they show very great unity of style. Quaternary cave art thus attests an organized collective manifestation of will, with a defined intention, and requiring the participation or approval of a whole society. One must not forget what months of work an artistic achievement of the scope of Lascaux represents. A solitary individual is not capable of accomplishing, even in part, such a work all by himself. The artist and his helpers, while engaged on it, must have been fed and protected by the rest of the tribe; raw materials must have been furnished to them; light, too,

49

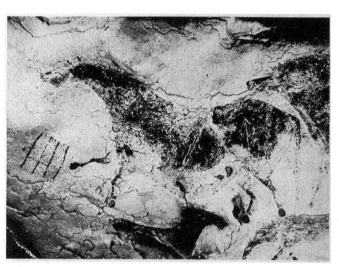

Nave, in niche on the left: group of engraved
and painted horses, Nos. 57, 58, 59 (see also
p 78), and 60. Their hooves and chestnuts seem
to have been retouched later in black. On the
largest, a pregnant mare (No. 57; cf. p. 44),
carefully engraved, are two darts (p 25).

and perhaps scaffolding. Moreover, painters
and engravers must have mastered the artistic
techniques of their day; and this implies, if
not an education in our sense of the word, at
least a sharing of vital ideas among these West-
European human groups in general. As for the
intention which inspired them to such works, it
might, on one view, be purely and sponta-
neously aesthetic. But on another view, it will
have been to serve their economic needs
through magic: and this is the view generally
held today. Many arguments, in fact, speak in
its support.

Amongst peoples of the present day there
are some who still have, or till lately had, the
custom of decorating walls of rock with symbols
and representations of animals. Amongst them
we can name the Bushmen of South Africa and
the natives of Australia. The Australians, the
most primitive of modern men, are still living
a Palaeolithic life, right in the twentieth
century. They furnish invaluable comparative
material to prehistorians, though, of course,
study of it can only bring out lines of suggestive
general resemblance. It has long been known
that the Australian natives decorate their
caves and their rocks, as well as their own
bodies, with red and white designs which have

a ritual meaning for them. Lately ethnologists have spent months with a desert tribe in Australia, and brought back films. In one of these an Australian, the head of the tribe, is seen actually decorating the wall of a cave, in just the way, perhaps, that our Palaeolithic ancestors did thousands of years ago. The sight is quite astounding. The film shows not an artist working, but a priest, or a sorcerer, officiating. Each gesture is accompanied and emphasized by songs and ritual dances, and these take a much more important place in the whole ceremony than the decoration itself. Ethnological comparisons can carry very far. There is no question, of course, of establishing

an actual connection, still less affiliation, between two phenomena so distant in time and in space as the Australian paintings and the Quaternary caves of Europe. The suggestion given us is only of the atmosphere in which our Palaeolithic caves can have received their decoration, bearing in mind that the rock-decorations of today have a ritual and sacred significance.

In any case, all that we know of the Palaeolithic caves confirms the modern view of the matter. From the first, explorers had been struck by the difficulty of access to most of the caves. Not only do the pictures start usually a long way from the entrance, often several

Nave (niche on the left): engraved and painted bison, No. 62, in black, with legs in deeper black, and reddish-brown mane and back. Length, about 4 ft. 6 in. He is pierced with seven darts, deeply engraved. In front of him, and fainter, is a blazon painted in black.

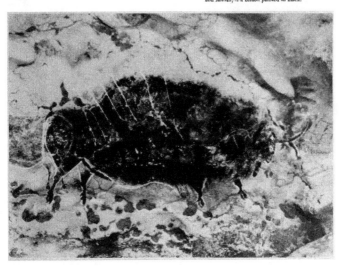

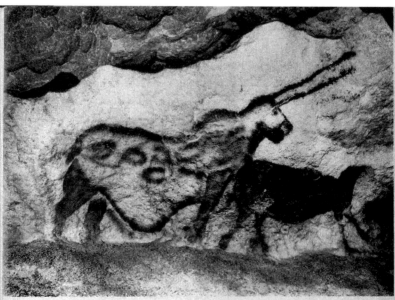

Main Chamber. 'Unicorn' (No. 2), or
imaginary animal, done in 'modelled'
technique in black, dappled with red.
Length about 9 ft. 6 in. The right fore-
leg is noticeably misplaced.

hundred yards, but also the decorations are
often tucked away in the most inaccessible
corners. In the 'Cave of The Horse' at Arcy-
sur-Cure it is necessary to crawl along for
several dozen yards squeezed as if between
pairs of rollers, and to leap over suction holes
and a vent in the rock, before reaching the
chief pictures. At Lascaux, indeed, most of
the chambers are big and easily accessible;
but one can only wonder what motive could
have impelled the artist to engrave the narrow
tunnel on either side of the Feline Chamber,
or to choose for the scene of the man, the bison,
and the rhinoceros, the bottom of a vertical
shaft several yards deep. The motive must have
been strong indeed to force him, as it did, to

work in the most uncomfortable positions, or
in dangerous places such as along the ledge be-
neath the frieze of deer. And these awkward
and strange locations are not all: there is also
the perversity of arrangement shown by those
figures which, without any apparent regard for
decorative purpose, are superimposed and
crowded on each other, while virgin wall right
beside them has not been touched. All these
phenomena are repeated from cave to cave.
They seem at once to imply a deliberate pur-
suit of the mysterious and secret: in fact, a
ritual intention.

When the first attempts to interpret Quat-
ernary art were made, at the beginning of the
twentieth century, certain prehistorians be-

52

lieved, with their leader Salomon Reinach, that the representations of animals decorating the caves were an expression of totemism—the study of this being at that time much in fashion. The bison, horses, mammoths, and so on, according to that theory, would have been animal totems, kinsmen and protectors of the tribe. And there are guides still who say glibly of this or that representation that 'It was a god.' As a matter of fact the theory has been completely abandoned. And it left much unexplained: if the totem of a society is defined as something unique in species, how can the variety of the representations be explained and, in most cases, the absence among them of any fixed hierarchy of types? Also, how can one explain the fact that animal totems, which should, of course, be protected by tabu, are so often shown pierced with arrows? These processions of animals, repeating their species from cave to cave, look very little like galleries of divine totemic ancestors. They look much more like hunting-pictures.

It is indeed around hunting that all the interests of Palaeolithic man are concentrated. The whole life of the tribe depends on the game which he brings home. The meat is used for food; the skins for clothing; needles and awls are made of the bones; the tendons serve for sewing, and also, no doubt, as bindings for the hafting of tools. Horns and antlers are of solid material, but easier to work than stone. The fat

Axial Passage. The 'Chinese' horse No. 45 Black outline, head and mane, and legs; incomplete body-filling of pale tawny colour touched over with black (cf. coloured plate, p. 18). The darts are dark brown Length, about 4 ft 6 in.

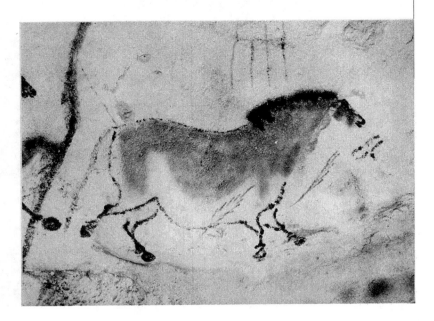

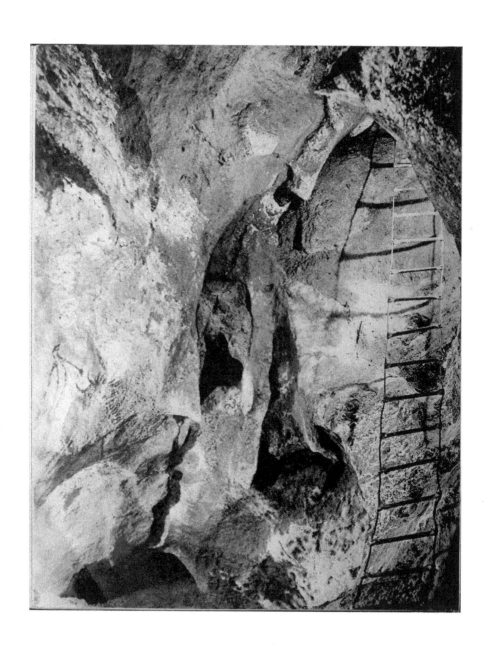

is used for lamps. On success in hunting the life of the group depends. But animals are swift and strong creatures; they know how to hide, and to fight. So man tries to conciliate the great unknown forces governing the world. Magic rites are enacted, in the mysterious depths of the caves, by sorcerers. Through their performances, tested by time and thence handed faithfully down the generations, the animals are held bound by magic force; they will fall victims to every trap, and every dart will kill them. Magic force, too, will ensure the abundance of the game-supply, the reproduction of animals that do man good and the destruction of those that harm him. Around this explanation, even though it may seem at first a mere flight of fancy, most of the known facts can be brought together and made intelligible.

The fauna which the decorated caves display is made up mostly of ruminants: carnivores, reptiles and birds are almost wholly absent. There are never any ornamental embellishings. Representations of human beings are very rare; plant representations (Lascaux has two) are still rarer, and of doubtful intepretation. The horse, at Lascaux as everywhere else, predominates. Then come ox, bison, deer and ibex. Together, these make up a carefully-chosen hunting quarry, difficult to come by, and upon which the whole heart of Palaeolithic man must have been set. These animal portrayals must have been designed for rites of sympathetic magic. Its secrets are totally unknown to us. But this form of magic, very general in the Middle Ages, and still practised sometimes in the depths of the French countryside, notably in Berry, is known to all primitive societies. It consists, fundamentally, in subjecting the image of an animate creature to what it is desired that the creature itself should suffer. For the image 'is' the creature; and through rites performed upon the image, the creature itself is got at. So it is that Negro sorcerers make an effigy of the person they wish to kill, and stud it with iron nails.

Many animals in Palaeolithic caves are portrayed scored over with various kinds of dashes, which can in most cases be understood without doubt as 'missiles', throwing-spears or darts.

These are animals destined to be killed, by the force of magic pantomime and spells. There are many examples of this at Lascaux. In the Main Chamber, the muzzle of the black bull (No. 18) is pierced by a long black dart ending in a hook. In the Axial Passage one of the cows on the ceiling (No. 44) has a forked dart stuck vertically into the scruff of her neck; a second dart is planted a little farther back, and a third, in black, thicker and with a hook, transfixes her rump. Two other cows (Nos. 24 and 40) are each stabbed in the chest by a short black forked dart. Another cow (No. 21) has her rump transfixed by a sort of bifurcated shaft, while flying round the 'Chinese' horses (Nos. 42 and 43) are darts of quite another sort, clearly shown fletched with feathers. But it is in the Passage on the right that transfixed animals are most numerous of all, perhaps because its walls will take engraving, which serves better than painting for the representation of long thin shafts. In a group of horses here (No. 57), one beast has seven long arrows scored parallel on his body; another has two. A little farther on a bison (No. 62) is pierced likewise by seven darts. In the narrow tunnel leading out of the Nave, one of the felines bristles with the engraved shafts of no less than twelve.

Moreover, the darts are not always depicted in contact with the animals, but sometimes above or below them and sometimes even by themselves. In the tunnel which extends beyond the Feline Chamber one can clearly distinguish a group of four darts engraved, recognizable by their tapering points; there are also two groups of seven parallel strokes, which are without doubt darts. Perhaps these representations of weapons were the object of special rites, to give them deadly force and aim.

Other weapons too are without doubt represented at Lascaux. Among them we can recognize the long spear or assegai, which in the Shaft scene (No. 52 bis) transfixes the wounded bison. In the same scene the hooked stick which lies at the foot of the human figure is probably a spear-thrower; with its hooked end and little crosswise handle, it is very like the

55

The Shaft: view of the foot of the descent. On the left can be seen part of the scene of the disembowelled bison (No. 52 bis) reproduced overleaf.

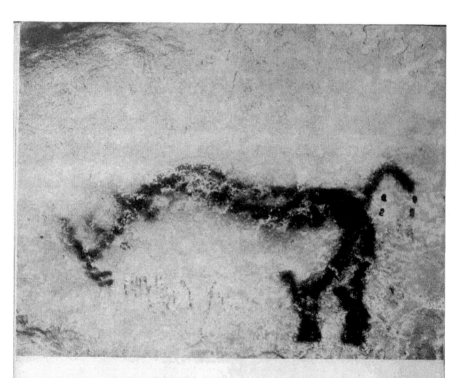

The *Scene in the Shaft*. Left: two-horned rhinoceros (*Rhinoceros tichorhinus*), done on the natural rock in black outline, thick but incomplete, the forelegs, throat and belly being merely sketched.

spear-throwers of the ancient Indians of Mexico.

But primitive hunters do not confine themselves to missile weapons. They make great use also of various snares and traps. At Solutré, in the Saône-et-Loire, in a big Aurignacian deposit at the foot of a high vertical cliff, were found the bones of several tens of thousands of horses. Various suggestions have been put forward to explain this extraordinary accumulation. The

most likely is that this cliff formed a natural trap, into which Aurignacian hunters drove the herds of wild horses; maddened by shouting and the wounds of darts, the horses threw themselves pell-mell over the precipice and crashed to pieces on the ground. It is probably a scene of this kind which is meant to be evoked by the picture of a falling horse, tawny with black mane (No. 51), at the end of the Axial Passage. The tortuous turn of the passage

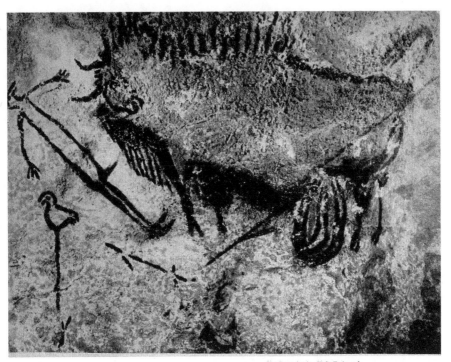

The Scene in the Shaft. Right and
centre: bison, wounded and dis-
embowelled, spear and spearthrower,
bird-figure on pole, and schematic
figure of bird-headed man. All in
black outline, appearing darker than
on left because done on a skin of
natural clay which here coats the rock.

is particularly favourable for the rendering of
such a scene, and the plate on page 62 gives a
very good idea of it. At Pindal, in the Canta-
brian Mountains, and in the cave of Ebbou in
the Ardèche, in similar pictorial conditions,
horses are depicted falling backwards; they
seem to come hurtling down into the void.
Almost all these scenes are of horses, to the
exclusion of other game; perhaps the large size
of their herds, and their high spirit and speed

of movement, favoured this type of hunting,
which till fairly recently was practised by
North American Indians on the bison, and by
the Lapps on the reindeer. However that may
be, the repetition of these identical scenes in
places so far apart, and their agreement with
what we know of the great charnel at Solutré,
cannot be fortuitous. These scenes must depict
a regular and habitual mode of hunting.

There are certain three-sided symbols, especi-

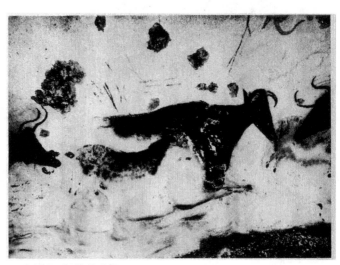

Axial Passage. Cow (No 25. cf. *Bos longifrons*), incompletely rendered in red ochre; horns curved down over the forehead (the only case of this at Lascaux). Adjoining, small horse, black and tawny. Length, about 2 ft. 8 in.

ally numerous at Font de Gaume, that were at first interpreted as pictures of huts made of branches; they were hence termed 'tectiforms'. And there are other signs, on cave walls in the Pyrenees and Spain, that in general appearance seem related to these 'tectiforms' although, in some cases, they have no resemblance to any sort of dwelling. These were given names like 'scaliform' or 'scutiform', which left them unexplained. However, Obermaier, towards 1918, and then Lips, and after them several other explorers, began to think that the tectiforms and other geometrically shaped symbols were perhaps traps. The association of these signs with the pictures of animals, and of Palaeolithic missile weapons and their frequent occurrence

in front of or below the animals and often superimposed on them, tell in favour of this interpretation. Lindner, in his study of prehistoric hunting, shows that the famous tectiforms of Font de Gaume may be traps of the type still used by the Blackfoot Indians in North America. However, comparisons between such Palaeolithic symbols and the types of trap used by existing primitive peoples have not yet been exhaustively pursued; it is only to the Font de Gaume tectiforms that Lindner's interpretation applies with any strong probability. And this interpretation does not solve all the problems; for, if the Quaternary artist really wishes to portray traps, why did he not do so in a more lifelike way, seeing that he

58

was able to achieve such varied and difficult animal portraits with incomparable mastery? Granted that he could not easily depict a geometrically-shaped object without taking into account perspective, the laws of which were unknown to him, yet even admitting this difficulty, it is still a far cry from the realism of the animal portraits to the schematization of these conjectured traps. Still, whatever may be the real meaning of these signs, they are certainly symbolic and they must have played an important part in the ceremonies of the cave sanctuaries.

The Abbé Breuil has thought it possible that the 'blazons' of Lascaux may represent tribal emblems; and these cross-ruled designs, carefully engraved and coloured, certainly suggest some such interpretation (see the photos on pages 64, 65). But since here they seem to play the same part, and occupy the same relative positions, as do the other geometric signs in the neighbouring caves, one is tempted to ask in what degree they can be explained by the trap theory, as propounded for the latter by Lips and Lindner. Quite strictly, it is conceivable that the lattice-design between the two ibexes (No. 37), and the one on to which the cow No. 40 seems to be leaping, may represent a trap or snare or net. The blazons painted in several colours and deeply incised, in the Nave

Axial Passage. Cow (No. 24: *Bos longifrons*), in red wash. The forepart alone is shown complete; the hinder part runs out into the bare line of rump and tail. On the left, a small horse in ochre, much effaced, is partly obliterated by the cow's head. Cf. p. 19; on the right are the 'Chinese' horses, Nos. 42–5.

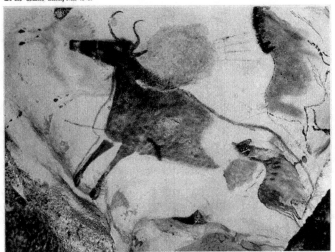

59

at the foot of the cow No. 65, do not suggest anything of this kind. And yet the similarity of all the geometric designs of Lascaux obliges us to admit that in all these cases the same object or symbol must be represented. If the theory of Lips and Lindner were to apply to the blazons of Lascaux, the schematization of the traps would be carried to its farthest point in the coloured chequers of the Nave. An examination of symbols of the same kind which are engraved farther on beyond the Feline Chamber complicates the problem still more. The care with which they are done shows up a number of details, some of which are repeated, but are difficult to see, on the blazons in the Nave. In at least one case these details call to mind quite astonishingly certain geometrically-shaped designs in the Spanish caves of Castillo and Altamira. This resemblance is only mentioned for what it is worth; but if

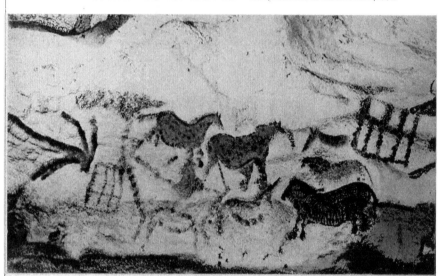

Axial Passage, the right-hand wall from Nos. 56 to 41. In the centre, a large ox or cow (No. 40: cf. *Bos longifrons*), of slender build, seems to be leaping towards a fence-like lattice, to be reckoned of the 'blazon' type (p. 65). It is painted in black, with its hooves in twisted perspective, and its near-side hind leg jerked up along its flank; its brownish appearance here is due to the superposition of the black over an older figure in red, not identified, which lies beneath.

60

subsequent comparative study were to confirm it, would it not be an argument in favour either of the trap theory or, anyhow, of the representation of some specific object? Certainly a technological contrivance, such as a trap, can be maintained over a wide area for a very long time; and it is harder to explain why tribal emblems—and in different periods, too—should be similar in France and Spain. But here we are in the realm of theory. The fact is that the meaning of the 'blazons' remains quite unknown, as does that of various emblems, dots, forked strokes, crosses, twisted and wavy lines, etc., scattered over the walls of the chambers and known to occur in the majority of decorated caves. We are ready to attribute to them a magic significance, in any case; but prehistorians and ethnologists at a loss for an explanation rarely fail to ascribe to ritual or magic what they do not understand.

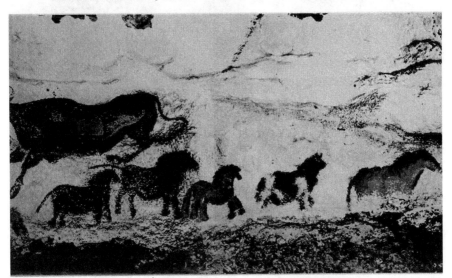

On the left, two ibexes (Nos. 56–7) confront each other across a latticed rectangle of the 'blazon' type: one is in black outline the other in black and yellowish dotted outline; their extremities can scarcely be seen. Next is a group of six horses (No. 58), dark tawny or reddish, dappled with black. On the right is a frieze of five small horses (No. 41), the smallest very like a modern Shetland pony. Length of the whole scene about 22 ft. 6 in.

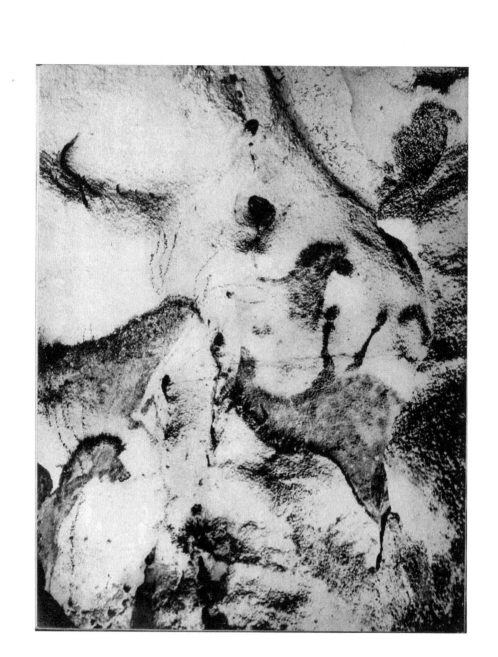

Other pictures help to give a glimpse of the sort of rites that may have been enacted in the silence of the sanctuary. Possibly the composite animal at the entrance of the cave (No. 2) might be a representation of a human being, disguised as an animal. Men masked in heads of animals and dressed in their furs, like certain witch-doctors of modern primitive tribes, are not unknown in Palaeolithic art. The most celebrated is the 'sorcerer' of the cave of Les Trois-Frères in the Ariège (see page 132). Should our 'unicorn' be compared to a picture of that kind? The animal is definitely in the attitude of a quadruped; this differentiates it from the other masked figures of the Quaternary period, which are usually semi-erect, and makes any conclusion impossible. One may, perhaps, allow that the two long streaks which seem to protrude from its head do not portray horns, but are remains of earlier paintings. Yet this unicorn, with its square muzzle, minute head, massive feet, and conically-sagging belly, does not represent any real Quaternary animal. Terminating, as here it does, a procession of such realistic other animals, it is a disconcerting feature.

It may be asked whether the oval spots spread over its skin represent natural dappling. Many Palaeolithic pictures of animals show circles or discs on the flanks, either painted or engraved, which are usually taken to be marks of wounds, corresponding to some rite of sympathetic magic. Instances of this are numerous. An engraving of a horse at Les Combarelles may be cited, and the great bull in the cave of Ebbou, and several horses and bovidae at Niaux. One bison at Niaux, in particular, shows this theory to be well founded. Its flank is marked with three cupulae, and a number of lines converge on each; it seems undeniable that the lines represent arrows, and the cupulae wounds. The seven or eight large and slightly flattened rings which appear on the 'unicorn', whether it be a mythical animal or a masked sorcerer, are perhaps something of this order. No other Lascaux animal bears a mark of a similar kind.

In Palaeolithic art beasts are also sometimes portrayed with long radiations springing from

the nostrils. These are either painted or engraved. They are usually taken to represent the blood or the breath of life flowing from the animal as the result of a wound. Examples are rare, but one or possibly two are to be found at Lascaux. A number of deeply incised rays protrude from the muzzle of one of the felines, and no doubt represent the same thing. The short black line emerging from the muzzle of ox No. 18 is more questionable, as is also a similar mark painted in front of the nostrils of one of the cows on the ceiling of the Axial Passage.

However, the most astonishing portrayal of a wound at Lascaux, and doubtless in all Quaternary art, is that in the Shaft scene. The bison has been wounded by the man's spear, or else by the horn of the rhinoceros moving away towards the left. Its entrails are falling out in great circles from its pierced belly. The realism of the scene is remarkable; but interpretation is not easy. Is it the 'narrative' portrayal of an episode that really took place? Was this drama painted in memory of a great chief, who died hunting the rhinoceros or the bison? It is a tempting explanation, and one which could be proved true if one day excavations should uncover a Palaeolithic burial at the foot of the picture. But nothing is less certain; and even so one has to explain why that schematic bird, perched on top of its stake, should be present at the scene, and also why the man stretched on the ground, dead or wounded, has hands with four fingers and a head ending in a beak, which is an exact replica of the head of the bird on the stake. Representations of human beings with birds' heads were already known before the discovery of Lascaux—as, for example, that in the cave of Cabrerets, which closely resembles the one we are dealing with. But their meaning is unknown. Do they portray a form of a hunting-decoy, a disguise permitting close approach to game? Or totemism? No one knows.

If the pictures of wounded or trapped beasts were used in ceremonies of sympathetic magic, it may be wondered what could be the object of the other animal pictures, so numerous at Lascaux, which have no sign or symbol with

63

End of the Axial Passage. Tawny horses with black manes and limbs (Nos. 29, 29 *bis*, 50, 51). The long straight stem-like lines are painted in dark ochre. Height just over 8 ft.

Nave. Blazon at the feet of cow No. 65 (cf. p. 86) in black, yellow, brown, and very dark red, about 10 in. square. Its painting and engraving do not exactly coincide. The two short vertical strokes engraved in the middle of its top are very clearly seen.

(Below) Nave. Blazon painted beneath the mare No. 57, in brown and black. The black dots within it are probably the remains of a blackish filling. The small black vertical strokes at the top and bottom of the compartments are all engraved and then painted.

them. It is possible that they express another aspect of the primitive idea that the image shares the essence of its living original, namely, that by multiplying the images one causes the living things themselves to multiply. This would explain the abundance of certain species, of horses and deer especially, which are often superimposed one on another, even when they are evidently drawn by the same hand or date from the same period. Moreover, there were rites of fertility and generation which no doubt corresponded to this concern for multiplying images. At Lascaux there are no examples of those scenes, sometimes found in Quaternary art, of males sniffing at their females; but on the other hand several females, whether cows or mares, are obviously pregnant. Yet in spite of this fact, the proportion of young animals is small. Except for the frieze of little horses (No. 41), of which it is hard to say whether they are foals or ponies, there is only one calf following its mother (No. 19). This calf can be seen in the photograph on page 92. Amongst pregnant animals the most remarkable are the wild ass (No. 27), perhaps the 'Chinese' horses (Nos. 42 and 43), and some other mares. The massive proportions of the horses, which obtain in all the breeds characteristic of primitive types, make it in many cases impossible to distinguish between a normal silhouette and that of a pregnant animal. On the main frieze in the Nave an enormous black cow (No. 65) is enthroned amongst several apparently pregnant mares, one of them (strangely, and in opposition to our theory) being pierced with arrows. Is this group fortuitous? Or was the site consecrated to special rites, performed with the object of assuring the fertility of the herds?

Many other unanswerable questions might be asked but, in spite of gaps in knowledge, some of which will never be filled, the significance of the rock paintings and engravings may be regarded as certainly magical. Fertility-rites and death-rites: these are the two poles round which the pictures in the ancient sanctuary were organized and ordered, just as the life of the tribe marched to the rhythm of the life and death of the big game. When the sorcerer enclosed himself for long hours together, in the recesses of these sacred caves, it was because upon him depended abundance or hunger.

And yet can one genuinely maintain that the requirements of magic and the chances of circumstance were the only causes behind the miraculous flowering of Palaeolithic art? Even if one grants that—as is very likely—exactness of representation was considered necessary or at least favourable to the success of the rites, and that, through stages of improving approximation, the first rough sketches on soft clay developed, independently of all aesthetic concern, into the gigantic bulls and noble stags and all the creatures portrayed in such life at Lascaux—even on this assumption, it is hard to admit that their authors worked quite without aesthetic consciousness.

Surely the admirable friezes of deer and ibexes, or the charming parade of little horses, or harmoniously balanced groups like the black oxen in the Main Chamber or the back-to-back bison in the Nave, could scarcely have been conceived and designed without any sensibility to beauty? At Lascaux the utilitarian and magical aspect of the figures, and their super-impositions, are dominated by the harmony of the whole decorative effect. And why wish to dissociate magic utility from artistic spontaneity? There is no more incompatibility between them than between religious faith and artistic creation. Who would dream of denying artistic gifts to the Christian Primitives on the grounds that their works are of religious inspiration? Besides, what is the beautiful? We really hardly know; and it is perhaps ingenuous to wish to fathom, after 20,000 years, the obscurities of the old cave artists' consciousness. The deep roots of art can be debated to infinity; but there seems no reason for us to deny to our Palaeolithic ancestors the sense and love of the beautiful. To conclude this chapter on the magic, the most characteristic signs and symbols of the cave have been classified. These signs, identical from chamber to chamber, and from cave to cave as well, have not been drawn by chance. They certainly are representations of objects or of definite symbols. Their interpretation, however, is often hazardous and nearly always impossible. Durkheim, in his *Formes Elémentaires de la Vie Religieuse*, tells how, amongst the natives of Australia, only the members of the clan understand the meanings of the symbols graven on their churingas. The fact must stimulate us to caution.

Nave. Blazon at the feet of cow No. 65 (p. 86), engraved and then painted in yellow, black, very dark red, and mauve. In the central compartment the borders of the painting and the engraving do not exactly coincide. Size about 9¼ by 9 in

(Below) Axial Passage. Blazon, in mauvish-brown, in front of the 'leaping cow', No. 40 (pp. 60–1), and thus looking like a kind of 'fence'. It has been partly encroached upon by calcite, and its details are not clearly discernible. Length, about 2 ft.

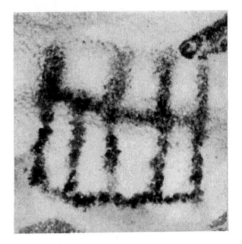

45

46

45*

45. One of the feathered arrows, dark brown in colour, which surround the 'Chinese' horse.
46. Geometric symbol outlined in black, accompanied by thirteen spots or blotches.
45*. Unfinished blazon or trap. Feathered dart. Indeterminate symbol in front.

15

18

17

15. Four symmetrically placed spots or blotches painted in black on the bull's flank.
16. Another series of black spots or blotches, painted above the 18-foot bull.
17. Typical symbol, frequently repeated with slight variations at Lascaux.

45**. Variant of the typical symbol shown above. Meaning uncertain.
18*. Schematised representation of a type of spear-thrower with transverse hand-grip.
21. Dart-symbol, no doubt marking the striking-point on the body of the desired animal.

*The Blazons.* Under this name are grouped all signs of rectangular shape. Their sizes vary from seven to twenty inches. They are either painted or engraved. Most are composed of a rectangular frame, divided into three parts equal in height and two parts unequal in breadth. One or two little vertical lines are often painted or cut in the upper parts of the vertical spaces. In some cases they only occur in the middle space. These are the typical blazons; rectangular signs with simpler divisions are probably akin to them.

There is no blazon in the Main Chamber. In the Axial Passage there is a typical one, painted maroon, between the two ibexes (No. 37). Another with irregular divisions, painted in dark maroon, is in front of cow No. 40 (see Fig., p. 60). A series of other signs is no doubt linked up with these blazons, such as a rectangle under the large deer, No. 46, and the design under the 'Chinese' horse, No. 45. But it would be risky to assign to this group an example of the type of emblem known as tectiform, well known in other caves, which occurs here above horse No. 45, and behind cow No. 44, or a series, near by, of three parallel strokes, or another of four strokes, also parallel, just visible under the horns of cow No. 24.

There is in the Nave, in front of horse No. 57, a blazon of typical shape, painted in brown and black lines, with several finely scored incisions. Under the feet of a cow, No. 63, there are three extraordinary blazons, painted thickly in black, yellow, red, maroon and mauve. They are very deeply engraved, but while the engraving follows the usual scheme, the colours

45**

18*

21

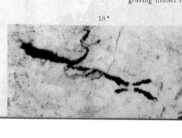

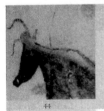

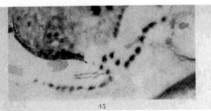

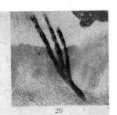

44

45

26

cover rather different divisions of spaces. In front of bison No. 62 two rectangular signs, not fully divided, are evidently related to this group.

In the narrow part which leads out of the Feline Chamber are two typical blazons, very finely engraved, without trace of painting. This delicacy of treatment shows up details of cross-hatching not found on the blazons in the other chambers. A series of four parallel strokes beside one of them is much like the series of strokes in the Axial Passage.

*Spear-thrower.* It is known that the bow was an introduction from the South and probably never crossed the line of the Pyrenees until the Mesolithic period. The Palaeolithic hunters of our regions, like the Eskimo of the present day, will have had to discharge their missiles by means of a spear-thrower. This is a sort of long shaft fitted with a heel, against which rests the base of the projectile to be thrown, the two shafts lying parallel together. The discharge is done by the usual movement, but with greater force and precision. A number of these hooked sticks have been found in Palaeolithic strata. The one depicted at Lascaux in the Shaft scene is exactly of the type of the ancient Mexican *atlatl*, found on the site of the great temple of Tenochtitlan; these were simple rods fitted with a hook at one end, and, at the other, with a crosswise peg for use as a handle. The *atlatl* threw projectiles of an average length of some four and a half feet, and it is not impossible that the long spear which transfixes the bison here may in fact be a missile discharged by such a spear-thrower.

44. Forked weapon, no doubt a hunting symbol, planted in the cow's neck (page 55).
45. Series of black spots or blotch marks painted in place of the horse's legs.
26. One of the rare symbols in the cave thought to be the representation of a plant.

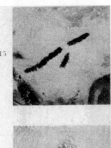

15

15. Black forked weapon on the chest of the bull, a frequent symbol at Lascaux.
28. Another symbol which could be classed, like No 26, as a plant-form
42 Feathered dart in dark brown, marking the striking-point on the body of the 'Chinese' horse.

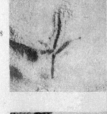

28

19. Series of red symbols, grouped freely together in front of the large cow.
23. Curious group of symbols, clearly drawn, above the unfinished cow.
45 One of the other dark brown feathered darts which surround the 'Chinese' horse

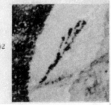

42

19

23

45

# Craft and
# Technique

# Craft and Technique:

# From Elementary Sketches to the

# Art of Painting

T HE Lascaux masterpieces form a whole which can easily be analysed into series. The large bulls in black outline at the entrance, the brown horses with black manes in the Axial Passage, and the back-to-back bison of the Nave, for example, were certainly not drawn by the same hand nor by the same process. Conversely, horses Nos. 32 and 33 and bison No. 54 show a striking resemblance to the oxen with conical muzzles on the ceiling of the Axial Passage. A study of the superimpositions of the paintings and engravings shows that these differences are not accidental. They are repeated in the same sequence on the different panels in the cave, and, more remarkable still, this sequence is found to be much the same in the other Palaeolithic caves, thus indicating a succession in time and marking the phases of an evolution. The decorated caves are real museums of Quaternary art, in which the works, instead of being grouped by periods in successive rooms, are scattered about

pell-mell and superimposed upon each other.

Sometimes the study of the superimposition of the figures encounters no difficulty. We have seen how in the panel to the left of the Main Chamber (see pages 76–77) it was possible to determine that bull No. 9 came before horse No. 8, or at least that its fore-foot did, because of the fall of a chip of rock. Under black bull No. 26, and easily distinguished as earlier, are two bovidae in dark red (to be clearly seen on the plate on page 88). Between the legs of bull No. 13 can be seen a little pale-brown deer, again plainly an earlier work. When a figure is both painted and engraved, it is possible to determine whether the engraving was done before or after the painting; if the incised stroke is not smeared with colour—and this is almost always the case at Lascaux—it is later than the painting.

On the whole, however, cases that can be interpreted so readily are seldom found. When engraved lines intersect each other, without any trace of painting, as occurs repeatedly in the Passage on the right, it is a very delicate business, and usually impossible, to decide which was executed first. It also sometimes

happens that the colours of two superimposed paintings have run into one another, and this makes it hard to distinguish which lay originally underneath. This occurs in marked degree in the Main Chamber, where it has seemed impossible to determine with certainty whether or not the large black band that forms the belly of bull No. 18 precedes the red filling which makes up the body of cow No. 19. Other examples in the same chamber have also seemed impossible to interpret. But infra-red photographs, which the wiring of the cave for electric light has lately made it possible to take (see pages 88–92), have now made exact data available for this purpose—the first time, as far as is known, that this technique has been used in the study of prehistoric art.

Naturally very many of the figures do not touch any others. Sometimes, their relative positions may indicate the probable order in which they were done. For instance, it can be taken for granted that the rump and feet of horse No. 12 have been omitted to avoid damage to bull No. 9, which must therefore have been earlier. It is also possible that the legs of cow No. 40 were represented as bent up to her flank in order not to encroach on the frieze of little horses. But there are few, if any, more such cases and their interpretation is anyhow hazardous. In fact, so long as the Lascaux superpositions are studied simply by themselves, their evidence remains scrappy—too scrappy to give the cave a firm chronology. Only by a comparison with the other Palaeolithic caves, completed by careful consideration of style, perspective and technique, has the Abbé Breuil been able to propound, in broad outline, a chronology for Lascaux.

It is not necessary here to go into the details of the thirteen successive series into which Abbé Breuil provisionally has divided the Lascaux pictures. But it seems desirable to summarize his chief conclusions, and show to which of these series he would refer the most characteristic pictures of the cave. Those of the Lateral Passage and other galleries on the right cannot always be exactly correlated with those of the Main Chamber and the Axial Passage,

but it will be interesting to note those correlations that seem in any degree likely.

The oldest work at Lascaux is no doubt the small outline of an arm in red, much obliterated, which the Abbé Breuil has detected on the left at the end of the Axial Passage. This would link up Lascaux with the very many representations of hands in the caves of the Pyrenees and Cantabria. Next follow small figures in fine line, red first, then yellow. In the plate on page 18 a small head of a horse belonging to this series can be made out in very faint red outline between the three heads of oxen on the roof. The group of little deer, No. 11, with very stiff legs in pairs together, also belongs to this early stage in the occupation of the cave (series 3); two of them have been retouched at later dates. Perhaps also to this stage, or one slightly later, should be assigned one of the ibex of group No. 57, drawn in brown dots. Drawing by means of dots is known to be an early usage in cave art. Numerous brown horses in the Main Chamber and the Axial Passage, some of whose manes were later retouched in black, form a fourth series, while the fifth is accounted for by various hardly recognizable traces. The oldest figures in the Lateral Passage, especially the frieze of ibex heads, No. 56 lvs, come probably fairly close in age to the preceding groups.

The next series consists of the two horses, Nos. 52 and 53, and the bison, No. 54, at the end of the Axial Passage. All three are done in red and are only partly filled in, most notably the bison. The body of horse No. 53 is streaked with long red lines, slightly oblique, which may represent either natural stripes, or else, for some obscure reason, the ribs of the animal. It is a rare but not exceptional case; a horse with similar stripes is attested by Count Bégouen at Niaux. Other examples are found in various caves, and at Lascaux, too, a small dark-coloured horse in the Main Chamber shows such striping. The hooves and muzzles of the three animals forming this sixth series, particularly of the bison, have been retouched in a darker tint.

Next come several horses of pale tawny, almost yellow, colour, the best examples being the

'Chinese' horses of the Axial Passage. With their black outlines, black touches on hooves and joints, and the modelled treatment of their filling-in (see especially the plate on page 18), the drawings of these animals show a technique far superior to that of the preceding series. To this group—the seventh series—belong the great brown deer, No. 46, and several figures in the Main Chamber, more or less hidden by later paintings, as for example the pretty deer, No. 16, and the brown bear, No. 17.

Horse No. 8 belongs to the next series. In spite of its red coat and its black head it is still a long way from the well-known paintings in polychrome. Its body, not modelled, is done in flat red colour, while the black of its head and its limbs was doubtless added later. The tawny horses with black manes at the bottom of the Axial Passage may belong to a parallel series, though they show a much more developed art than this red and black horse.

With the ninth series we reach the magnificent bulls of the Main Chamber; of this style also may be reckoned the second ibex of group 57, and possibly, as well, the 'unicorn' at the entrance. The animals treated in flat red colour, such as cows Nos. 14 and 19 in the Main Chamber, have seemed perhaps to belong to a later series, since the inter-relation between the two was not very clear. 'It does not seem certain to me', says the Abbé Breuil, 'that the red may not appear superimposed over the black only because, being the richer colour, it has predominated over the black at their points of contact.' The infra-red photographs, in our opinion, settle this contentious point once and for all (see pages 88–92): the black bulls are the later. It is also worth noting that the hind legs of the great bull, No. 15, are lacking. Was the artist impeded in his work by the presence of cow No. 19, which in that case will have preceded the bull?

An eleventh series consists of red animals with black heads done over the traces of series 5. It is magnificently represented by the cows on the roof of the Axial Passage. These are superimposed on some attractive brown horses of series 5—actually, they were never completely finished.

The twelfth series consists of many horses in a uniform black. In the Main Chamber the rump of one of them encroaches slightly but unmistakably on the 'unicorn'. The four little horses of frieze No. 41 belong to the same group; and so, probably, do several black retouchings of the horses of series 4, 7 and 8, and possibly the dots in the Axial Passage.

The thirteenth series comprises animals done in genuine bi-colour, which are not to be confused with those done first in one colour and afterwards touched up in black, like horse No. 8. The beautiful horse's head, No. 12, as well as a red and brown ox hidden by bull No. 26, are its best examples. After this bi-colour group, but still close to it, come two magnificent figures all in black, bull No. 26 and cow No. 40, who seems brown rather than black because she has been painted over an older red figure, still unidentified. The Abbé Breuil now wonders whether the tawny horses outlined in black, which he had placed in series 8, should not, after all, be included in this series 13. We readily agree with this suggestion because of the resemblance in technique. The enormous black cow, No. 63, in the Passage on the right, is also allied to series 13. Finally, in spite of the difficulty of dating the pictures in this Passage, we can take it that the large frieze of deer No. 64, for reasons to be seen later, is the latest work in the whole cave.

All the series thus distinguished by the Abbé Breuil have a certain number of points in common, and their distinction seems to depend more on questions of technique and process than of style and conception. Whatever the successive stages which the Lascaux paintings represent, we get from the whole a strong impression of unity, as we do, indeed, from all Palaeolithic cave art. This impression is not due only to its uniformity in raw materials and its consistency as decoration, but, and transcending a certain diversity of process, to a real unity in the choice of subjects, in their composition, and in the realism of their execution.

Quaternary art is above all an animal art. A curious fact, and one which I believe to be unique in the history of art, is that no scenery is ever depicted. A few representations of plant

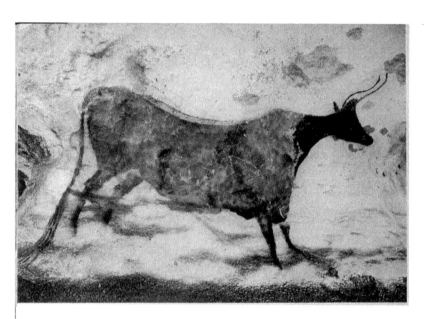

Axial Passage Red cow with black head
(No. 21. cf. *Bos longifrons*) The red
seems to have 'run' on the white rock.
The dappled effect is due to the paint-
er's technique of filling-in  Length
about 9 ft.

life are occasionally found (at Lascaux a
spreading branch, painted in dark ochre above
horse No. 29 at the end of the Axial Passage,
and a possible creeper, No. 53, engraved in the
Apse), but these are nearly always isolated and
do not seem intended as scenery. No line is ever
drawn for the ground. On the other hand it is
conceivable that the natural formation of the
rock walls was sometimes used purposely as a
framework for the pictures. This is perhaps the
case with the sunken rocks between which the
brown and black horse, No. 31, seems to be
throwing itself. It is certainly the case with the
ledge of rock skirting the walls of nearly all
the chambers, along which most of the animals
run (see plates on pages 76–77 and 60–61).

74

The artist no doubt felt it as a ground line;
perhaps also as a water line, if frieze No. 64
does indeed represent a herd of deer swimming
across a river. But that was only a more or less
conscious utilization of a natural accident, and
the Quaternary artist never seems to have hit
upon the idea of creating scenery for himself.

In 1936 an inventory was published by
Herbert Kühn, in Vol. IV of the *Zeitschrift für
Rassenkunde*, of all the Palaeolithic repre-
sentations of human beings so far discovered.
There were no fewer than 158; but for our
purposes 59 of these may be subtracted, as
being Aurignacian statuettes of a different
character, which do not here concern us. That
leaves some 99 human representations, not all

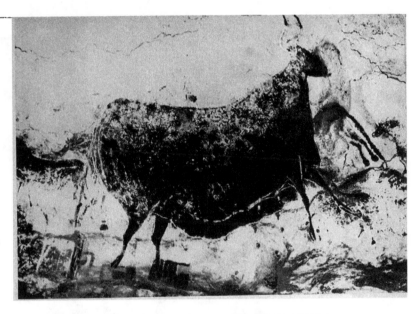

Nave, central subject of the left-hand wall. Pregnant cow (No. 65: cf. *Bos longifrons*), painted in flat black colour. The hooves, in twisted perspective, can be seen to be later than the blazons below them.

from cave or rock-wall art, but including carvings on ivory or bone. Compared with the thousands, perhaps tens of thousands, of animal representations, the total is quite tiny. Man in cave art may not be positively exceptional, but he is at all events very rare. And what is especially remarkable is that nearly always he is shown as masked. At Lascaux, what is the meaning of the stylized man with the bird's head? Why did the artist, who could do life-portraits of beasts as difficult to observe as a bison or rhinoceros, draw the man only in such clumsy outline? It appears that the man was drawn in this as in most other cases, not as an individual but as a sign or symbol. The real subject of the picture lay elsewhere.

Apart from the few exceptions mentioned above the subjects treated by Quaternary artists are all animals, and, moreover, animals very particularly chosen. Nearly all the figures in the caves are of the larger mammals, especially ruminants. There are occasionally birds and snakes, one wolverine, two or three wolves, some felines, a few fish, a seal, even, and a winged insect, but most of these exceptions occur among the figures done on portable objects, and in any case they form only a minute proportion of the sum total of the representations. Quaternary art has for practically its sole subject not merely the animal world, but a clearly defined part of that world —the part that is killed and eaten. This unity

75

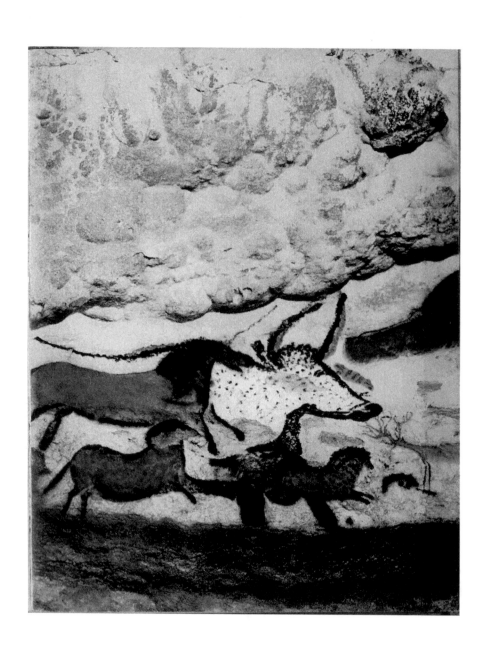

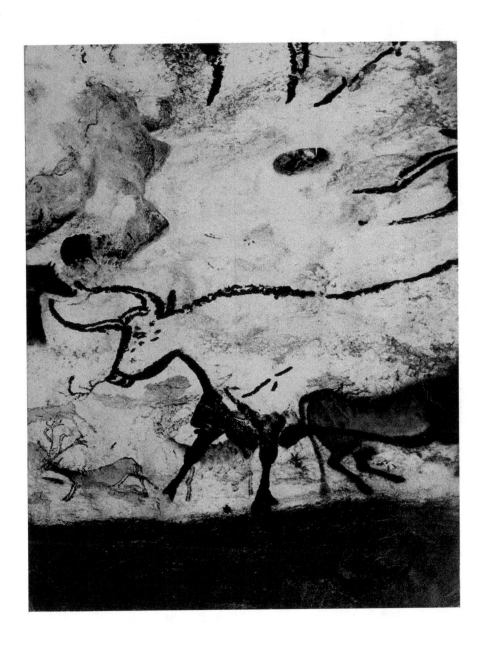

Nave. One of the horses in the niche on the left, No. 59 (for the rest, see p. 50). Painted in brownish-red ochre, and with seven parallel darts engraved on its flank. As with the other horses in this niche, its chestnuts seem all to show subsequent retouching.

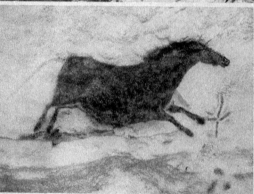

Axial Passage. Horse, No. 28, in nigger-black; for detail of its head, see p. 80. There is a noticeable disproportion between its head and fore quarters, as in most other Palaeolithic portrayals of horses. Length about 9 ft. 9 in.

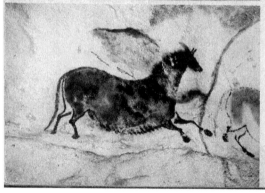

Axial Passage. 'Chinese' horse, No. 42, placed within the rump of ox No. 24 (cf. pp. 18, 59). It is painted a dark tawny colour, dappled with black, and so are the darts above its back.

Coloured plate on the preceding pair of pages (pp. 76-7). Group of paintings in the Main

Main Chamber. Small red deer, No. 16, finely drawn and painted a dark tawny, with the black throatline of bull No. 15 (see bottom of page) running superimposed upon it. It differs considerably in its antlers from the other deer at Lascaux. Length, about 2 ft. 4 in.

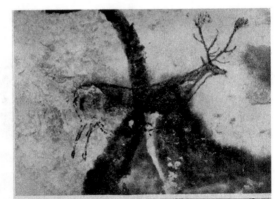

Main Chamber. Brown bear, No. 17, facing to right, painted in nigger within the thick black belly-line of bull No. 15 (see below); projecting above this can be seen its muzzle, ears and humped back, and below it the claws of one hind foot. Length, about 5 ft. 5 in.

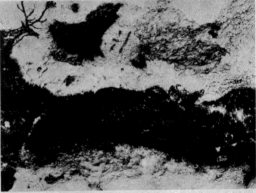

Main Chamber. Bulls (*Bos primigenius*) Nos. 15 and 18, executed in modelled black. Around and between their legs can be seen various other animals, among them the deer and bear (Nos. 16 and 17) (see above), and to the right a cow, No. 19, p. 92. Length of No. 15 about 14 ft. 6 in

Chamber, Nos. 6–14 (pp. 20, 26, 95). Total length about 26 ft.: height about 8 ft. 6 in.

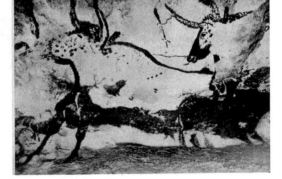

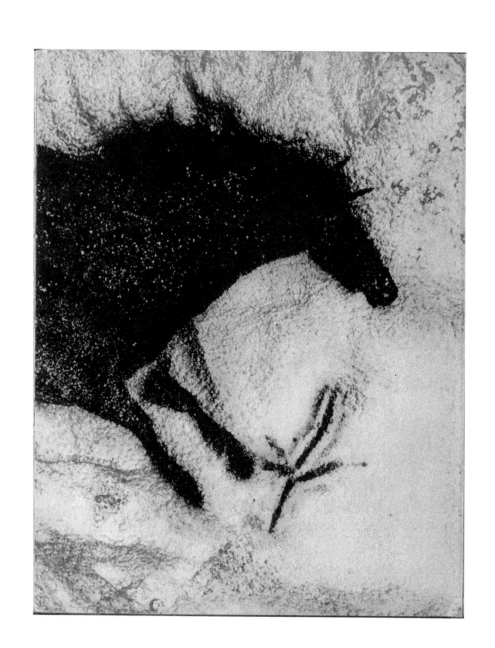

of subject lends an extraordinary unity to the whole achievement, and it is emphasized by the presence of the 'emblems', which are more or less similar in all the caves, and give them a distinctive mark of character.

Another character of Quaternary art, on which emphasis has often been laid, is that composition, as such, was not understood, but only the portrayal of subject in isolation, without reference to proportion or position. There are, of course, exceptions. Certain scenes, frequently cited, have become classic, such as the deer crossing a river, found engraved on antler in the cave of Lorthet, or the clay bison of the Tuc d'Audoubert. But the great majority of Palaeolithic pictures consist of animals placed one on the top of the other or scattered about on different planes without apparent regard for composition. The discovery of Lascaux has thrown rather a new light on this question. Even if we disregard the scene in the Shaft as too exceptional—it must surely be a narrative picture, however one explains it—many of the groupings seem genuinely to have been composed.

Groups such as the ibexes of No. 37, the horses, Nos. 58 and 41, the deer of No. 64, and the back-to-back bisons of No. 65, impress themselves immediately on the observer as compositions, and there is no reason for believing that they were not executed as such. But are they simultaneous portrayals of a number of specific animal subjects, or repetitions of the same subject with a purpose intended to be decorative? It is a nice question. The fact that one group should have been composed at two different times, such as that of the two full-face ibexes, No. 37, is an argument in favour of the second theory, but an examination of the deer crossing the river, where the first is raising itself as though to land, inclines one towards the first. However that may be, these groups prove that their creator had already developed a certain sense of composition.

The existence of this sense is nowhere contradicted, throughout the whole occupation of the cave from the earliest series with the frieze of ibex heads, No. 56 bis, through the seventh, with the Chinese horses, the ninth with its

great black bulls, and the oxen with delicate heads in the eleventh, down to the deer of the latest series, No. 64. And, remarkably enough, if the relative chronology of the works that we have just recounted is correct, the composition of the earliest friezes is as perfect, in conception and in execution, too, as that of the latest ones. The artist seems at the very outset to have grasped its principles. The walls of the cave have left no clumsy attempts at the simultaneous portrayal of several animals—unless, indeed, one were so to explain the lack of order which is displayed by the majority of the paintings. We discern no stages in the art of composition; admittedly, it has not been made use of often, but that is perhaps only because the purpose of the sanctuary did not often need it.

Quaternary art is very readily described as realistic—a realistic art being understood as one which sets out to produce images with the closest possible resemblance to real objects, and in particular to living beings. But this resemblance is sought, in the majority of cases, not in the exact reproduction of a multitude of details, but in the selection of certain features considered as essential. Details, indeed, in Quaternary art are frequently neglected. Belly line is left out, and in a certain number of pictures an animal's extremities, which we tend to think indispensable, do not appear at all. There is no need to cite examples: it is enough to turn over the pages of this book to recognize the prevalence of this process of outlining an animal rather than showing it in detail. Nor would the raw materials, the artist's tools and the irregularity of the rock itself have lent themselves to the execution of details. It remains true, however, that as soon as we reach the galleries containing engravings, details become more frequent.

The fact is that Palaeolithic realism consists in denoting a characteristic attitude, like that of the bison raising its tail, or a distinguishing feature of a species, such as horns or coat, and not in an attempt to portray nature 'photographically'. It is reinforced by the very distinctive process of using the natural unevennesses of the rock, perfecting them, if necessary,

81

Axial Passage. Horse No. 28, in nigger, with skin dappled, and muzzle and ears retouched, in deeper black. Much flecked with calcite Length, about 9 ft. 9 in.

Nave. Eight heads of ibex (No. 56 *bis*), engraved and painted. The left-hand four have heads painted black and horns red; the right-hand four have red heads, but have lost virtually all trace of painting on their horns. Height, about 16 in.

by scraping, and tracing the outlines of the animals so as to coincide with them. This process is common in cave art, and several examples of it at Lascaux are particularly successful; the rumps of horses Nos. 32 and 33 coincide exactly with a projection of the rock. The eye of horse No. 52 is a natural round hole with calcite issuing from it. In the photograph it is not clear that the back of horse No. 12 is equally marked by a sudden unevenness of the rock which has been deepened and smoothed by human hand. Finally, the muzzle, the brow, and the dorsal hump of the small bear, No. 17, are entirely in relief, and give the animal, from close by, a strangely life-like appearance.

As Luquet has shown, realistic representation can be based on two different principles, which are very often applied unconsciously. On the one hand, the artist's concern may be not for what he sees in a subject, but only for what

he knows is there; his realism is therefore intellectual. Young children, whose drawings tend to show analogies to those of primitive peoples, will often do a human face with its two eyes frontally and its nose in profile, or a reel of cotton with top and bottom both showing at once. On the other hand, the artist may wish to reproduce whatever he sees of his subject at a given moment from a given point. His realism is thus visual. This appears in children of about six or seven years old; from that age onwards they only put one eye and one ear in profile drawing.

The question of realism, whether intellectual or visual, covers also that of perspective, for to observe the laws of perspective is to reproduce things as they are seen, while to ignore them is to represent things as they are known to be. Almost always in Palæolithic work, as in children's drawings, animals are shown in profile,

and thus the problem of perspective arises chiefly in the rendering of feet, with their hooves, and of heads, with their ears, horns or antlers. Palaeolithic artists often solved this problem in a special manner, called by the Abbé Breuil 'twisted perspective', and attributed by him to the Aurignacians. The pair of horns or antlers, or the two divisions of the cloven hoof, are seen from the front, though the rest of the animal is shown in profile, so that in reality one of the horns or hoof-divisions would be hidden by the other. Carried to its logical end in the case of an ox, for instance, this method will show, on the head, both the horns and both the ears, the latter being placed either behind or on each side of the horns, and on the hoof, both the divisions (the cleft between them being really on the front) and both the dew-claws (really on the back), these being drawn either one on the top of the other or one on each side of the foot. But twisted perspective is rarely applied as absolutely as this,

and never so at Lascaux. It can be seen here in various different degrees, which lead up to a perspective much closer to visual realism.

There is little to be said of the perspective of the ears of animals without horns or antlers. Ears, of course, are movable organs, and most of the renderings are not exact enough to show just where they join the head. The very widely separated ears of horse No. 28 seem inspired by intellectual realism, but those of horses Nos. 12, 31 and 42, for instance, are set fairly correctly. Anyhow, with the horse, as with the bear or the rhinoceros, this technical problem is easy to resolve.

In portraying the heads of deer, on the other hand, it is difficult to avoid confusion, since antlers and tines have to be shown which are really disposed perpendicularly to the plane of the picture. The Lascaux artists got out of the difficulty in various ways. The antlers of one of the deer of group No. 11, which are conventionalized anyhow, are shown diverging, that

Nave (upper register). One of the horses of the frieze No. 65 *bis*, engraved and painted black: they are done one inside the other and half obliterated, but on the flank of this horse the engraving of at least one smaller one can be clearly seen.

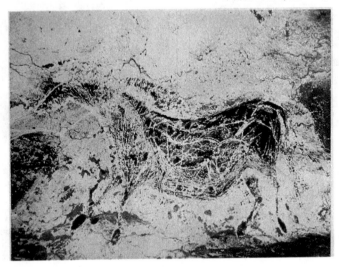

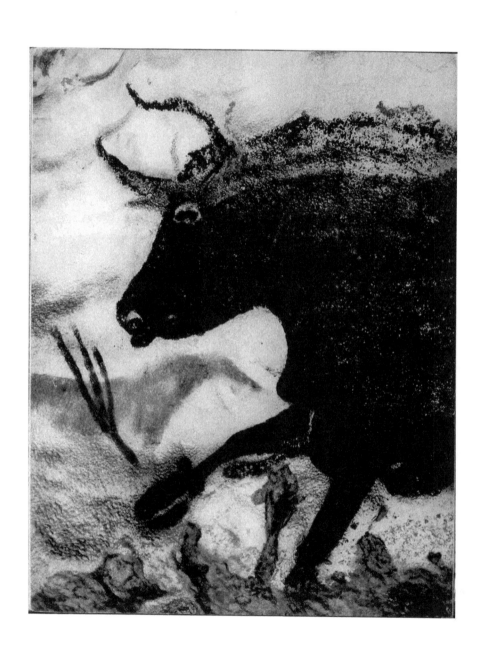

is, in twisted perspective; but otherwise, except for a few drawings in the Apse and the small deer, No. 16, the twisted perspective is modified and eased. The great deer, No. 46, has its two antlers shown in profile, but to avoid their superimposition the artist has erected one almost vertically and thrown the other right back. This proceeding is modified in frieze No. 64, where the antlers, except in one case, diverge much less. In portrayals of the ox tribe, although ears never actually figure on either side of a pair of horns, twisted perspective appeared in its most interesting forms. However, as Luquet remarks, the interpretation is not always as self-evident as it at first appears. 'To judge by present-day representatives of the ox tribe, horns will differ from one individual to another both in their general shape and curvature and in their setting and direction; as a result, when these horns are very far apart they can assume, to an observer seeing them from the side, and especially from a three-quarter angle, an aspect much like that which they present from the front. It is thus possible that oxen in profile with horns apparently full-face are closer to visual realism, after all, than would have been thought at first sight.' Allowing for these reservations, an examination of pages 114 and 115 shows the convention of twisted perspectives in several different forms. These run from the divergent horns of bull No. 15 and the queerly twisted horns of cow No. 44 to the more and more parallel ones of Nos. 65, 40 and 21. In the Apse the heads of the two bison, No. 65, are shown completely in profile, with a single horn, while all four legs of them appear. The case of cow No. 23 is doubtful; it is not clear whether two short parallel horns are portrayed on her head, or only the two edges of a single horn.

The horse's hoof, surmounted at the back by the single projection of its fetlock, displays its form most characteristically in profile; no problem, therefore, arises in its reproduction. On the other hand the hooves of the ox and the deer tribes are cloven vertically on the front into two divisions, and behind there are two

Axial Passage. Horse (No. 55), in red ochre, incompletely filled in. The line of the back follows a natural relief-contour of the rock, and a hole in the rock forms the eye.

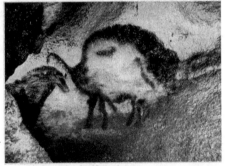

Axial Passage Bison (No. 54), in red ochre, very incompletely filled in, on its flank is a broad black patch.

(Below) Two wild asses (No. 27), one evidently (perhaps both) pregnant.

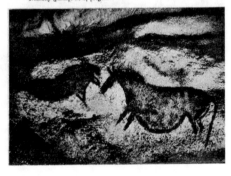

Axial Passage. Black bull (No. 26), superimposed on numerous oxen in red, of which portions of rump and legs (below) and horns (above) can be seen protruding from beneath it

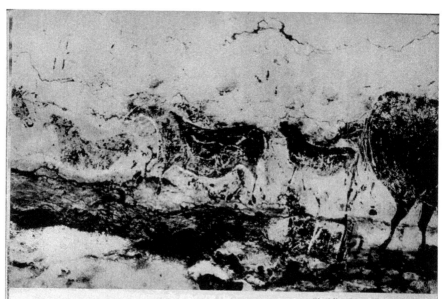

(Above) Nave. Frieze, starting on the **left with numerous horses, engraved** and painted in black previously to the cow in the centre. Their extremities have been retouched, most probably later, in deeper black.

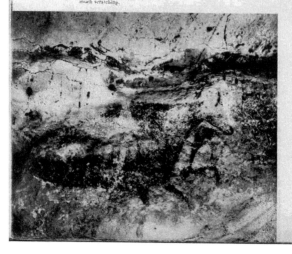

(Below) Ape. Horse (No. 55 *bis*, painted in black, forepart and belly alone clearly discernible; traces of much scratching.

dew-claws, a little way up and on a level with each other. In the Lascaux oxen all hooves, if they are shown at all, are in twisted perspective, while the rest of the leg is seen in profile, so as to allow emphasis on the dew-claw (both dew-claws are never shown), and likewise on the knee-joints (see pages 120, 121).

While this curious form of twisted perspective is used for the extremities of the Lascaux animals, their four legs are portrayed in normal perspective. They are not shown alongside one another, as intellectual realism would demand and as is sometimes the case in very primitive drawings in other

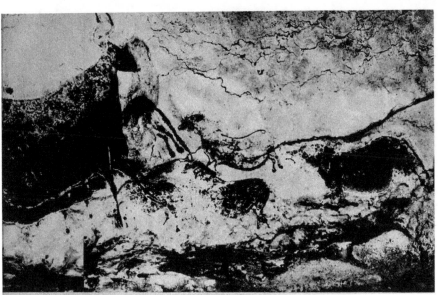

The cow in the centre (No. 65: cf. *Bos longifrons*) is enormous, and seems pregnant. Beside her hind feet are three blazons (pp. 54–5), also engraved and painted. To the right, more horses, a good deal effaced.

(Below) Apse. Deer (No. 56), perhaps wounded by dart; ill-preserved but for the antlers, fore-quarters, and kneeling legs. The walls of the Apse carry many traces of other deer besides.

caves, but with the two near-side legs well on top of the other two, half-hiding them. The modelling of the thighs, indeed, is usually very well done. This is true both of the farthest-evolved and of the oldest series. The front legs of bull No. 26, those of the cows on the roof of the Axial Passage, and those of the great black cow in the Nave, are seen from a three-quarter angle and are very close to nature. A very few animals are seen from the back. This is probably the case with the horse falling upside down at the end of the Axial Passage, and certainly with the animals in the Shaft scene; the rhinoceros leaving the outstretched

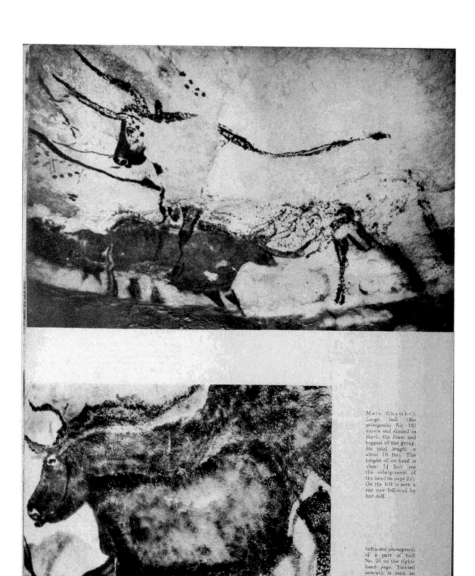

Main Chamber. Large bull (*Bos primigenius* No. 18) drawn and shaded in black, the finest and biggest of the group. Its total length is about 18 feet. The height of its head is about 5½ feet (see the enlargement of the head on page 22). On the left is seen a red cow followed by her calf.

Infra-red photograph of a part of bull No. 20 on the right-hand page. Painted beneath is seen an ox, rendered in full-colour technique, which confirms its priority to the bull.

Infra-red photograph of another part of bull No. 26. The remark made on the opposite page applies here also. At the back, the black in part predominates over the red of the underlying animal.

Axial Passage. Central subject of the right wall. Large bull (*Bos primigenius*, No. 26) executed in flat black colour. The upper line of the neck has been several times touched up. One of the hoofs is shown in twisted perspective. In front of the bull is a large branched symbol painted in black.

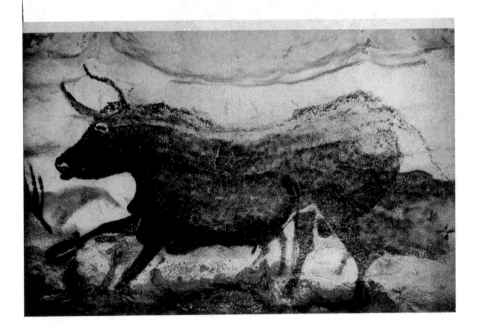

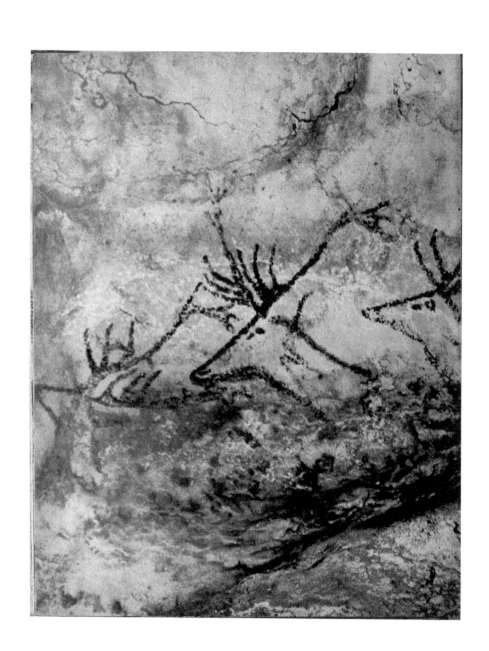

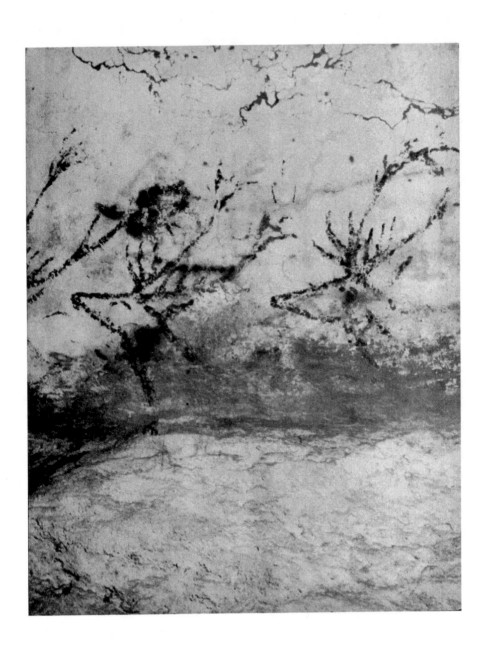

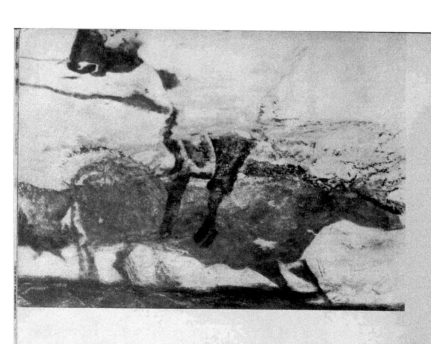

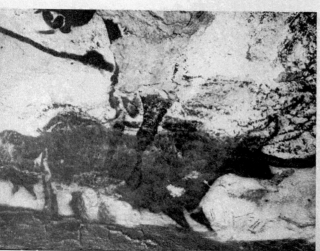

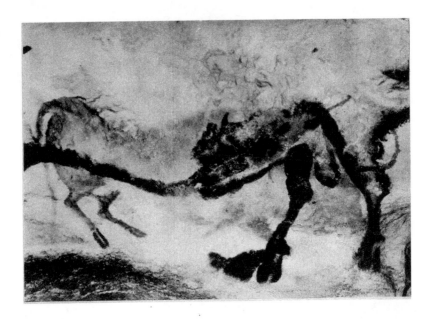

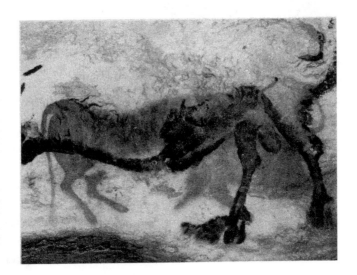

(Above) Infra-red photograph of the subject below, showing the black bull, from the lines of his nether parts, to be certainly superimposed upon the smaller red ox.

Main Chamber. Ox (No. 14), in flat red colour, with the nether parts of the larger black bull, No. 15 (p. 77), apparently superimposed upon it. For proof of this as fact, cf. the photograph above.

Preceding pair of pages (pp. 90–1), *continued*. The antlers of these deer, with their three brow lines, are remarkable. The leading deer seems to be throwing his head back, as though about to land after the swim.

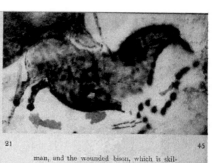

21

45

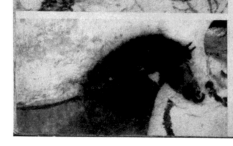

9

man, and the wounded bison, which is skilfully represented as though seen from behind and yet turning its head.

Whether it be visual realism, expressed by methods both simple and powerful (use of relief, emphasis on characteristic features and attitudes), or intellectual realism, restricted within notably precise limits, what lies at the root of the Lascaux art through all its periods is at all events realism. There is no symbolism nor, except in the Shaft scene, any schematization. And when the signs that we have called symbolic are found scattered over the cave-walls, they may be subsequent additions, superimposed on the animal subjects, but they do not interfere with their character. Nor, when there emerge any clearer suggestions of a deliberately decorative purpose, are they ever carried to the point of stylizing the elements of a picture.

No. 21, cow (red, with black head) (p. 74): detail, showing the line of the back done twice over.

No. 45, horse (p. 24), the filling-in tawny, in modelled technique, the mane, legs and belly in black line, the neck in dotted black. Forelegs missing.

No. 9, bull (p. 26): detail, showing scar on cheek from the scaling-off of a flake of rock, apparently before the painting. From beneath the horns and muzzle those of an earlier bull beneath can be seen emerging.

No. 12, horse in dark red (pp. 76-7, centre): detail, showing the smoky black of the mane, apparently sprayed on by blowing.

No. 2, the 'Unicorn' (in black and dark red) (p. 54): detail, showing slight formation of stalagmite in the crevicing across back and head.

12

2

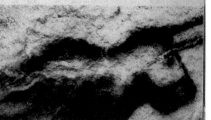

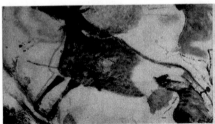

24

44

The processes and techniques used in creating works of remote antiquity are not directly known to us. We can only try to reconstruct them hypothetically by an examination of the paintings, by chemical analysis, and by ethnographical comparisons.

All the colours used by the Palaeolithic artists have a foundation of mineral oxide. They may perhaps have known colours based on vegetable and animal products (blood, decoctions from leaves, etc.), but these would be much more fragile, and have never come down to us. Mineral oxides usable as colouring matter are very abundant in nature, but are not very varied. The base of all of them is either iron or manganese, and they produce, with all their intermediate tints, the three fundamental colours black, red, and yellow, which are characteristic of Palaeolithic painting. Of white, so much used among modern primitive peoples,

11

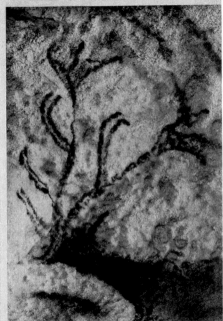

No. 24, cow on the roof of the Axial Passage (pp. 59, 96): detail, showing incomplete filling-in and line of chest and foreleg done twice over—a characteristic example.

No. 44, cow (p. 24) in brownish red: detail. The filling-in, by the grading downward of its tone, gives an impression of modelled relief.

No. 11, one of the group of small stags (pp. 25, 77): detail. The head and antlers seem to have been subsequently restored.

No. 20, section of the rocky talus at the entrance of the Lateral Passage (p. 40): detail, showing the skin of calcite (above) standing out against the rock.

No. 8, horse (p. 20): detail showing the left foreleg to have been painted or repainted after the scaling-off of the rock here visible (cf. p. 20).

8

20

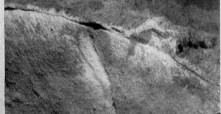

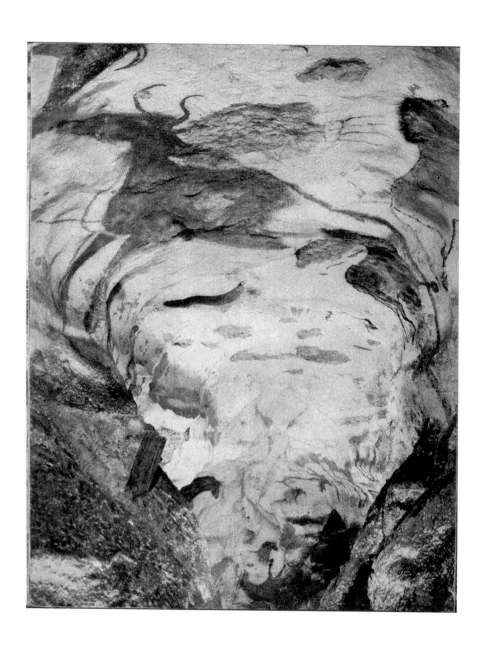

there is no trace at Lascaux. It is general to find the natural colour of the rock used as a pale background for bas-relief effects; but it sometimes happens, as in the case of the hands at Gargas and Niaux, that the subject shows up flesh-coloured from a background painted black or red. No hands of this type have been discovered at Lascaux.

The oxides of iron, which are found in the form of earthy lumps, rich in clay and sometimes compact enough to be cut up into pencils, produce red and yellow ochres varying in range from a reddish brown to straw colour. Natural peroxide of iron is transformed slowly and naturally into violet oxide. It is perhaps the basis of the red-violets and the mauve observed at Altamira and Lascaux. The manganese oxides, to be found in the cave-earth floors in the form of thin layers or pockets of black granular matter, supplied the Palaeolithic artists with their blacks. Their range of tint is much smaller than that of the iron oxides, but two quite different blacks are distinguishable: one clean, the colour of coal, the other a very dark nigger.

These mineral oxides were certainly used crushed as finely as possible, this being a necessary condition if they were to stick on. Furthermore, at Lascaux and in other caves, naturally-hollowed stones have been found, or shoulder-blades of large animals, which are stained with colours and have almost certainly been used as mortars. The paint thus obtained was doubtless never employed in the form of powder, as this would have been extremely fragile. It was diluted either in water or more probably in animal fat or in urine, as is done by some primitives today.

The paint thus prepared was applied by various processes. These do not seem to have been all used simultaneously, and the way in which one was followed in use by another has helped to distinguish several stages of artistic evolution. The reconstruction of these pro-cesses is very hypothetical, but sometimes an unfinished work, like the rhinoceros in the Shaft, or alterations, such as are found on the back of the great black bull in the Axial Passage, give us a vivid impression of the Quaternary artists' methods. The work was at first roughed out, then worked over in detail. The first sketch was done either in thin line, lightly traced, as in the two examples just quoted, and in cow No. 44, or else perhaps, in work probably older and of very different technique, by means of a series of coloured dots, more or less covered afterwards by the filling in. These dots are clearly visible on a number of animals, for instance, deer No. 46 (the back), horse No. 35 (the chest, belly and tail), and the 'unicorn' (the belly).

After the sketch had been made the work was finished by various methods. At Lascaux we have got far beyond the first attempts at painting, done by direct application of the hand stained with ochre on to lighter walls. The artist had to work according to technique as well known and tested, handed down from those before him. Certain paintings, thick and uniform in colour, seem to have been washed on with a pad of lichen or moss, or with a brush made perhaps out of a tuft of hair, or else by the sliced-up end of a stick. Other paintings, known as surface-coated, have their surface clotted over with colour, probably in the same sort of way, but with less and thicker liquid. Finally, many of the figures have almost smoke-like outlines, especially the black manes of horses (e.g. No. 12, p. 94), while in others the filling-in looks mottled; here the paint seems to have been blown on. How was this done? We know that some Australian natives blow on their colours through a hollow tube. The Palaeolithic artists may quite well have used a similar method. If so, it would explain some of the hollow bones which have been found, filled with ochre, in cave-strata. These will have been the first vaporizers.

Axial Passage. Cow, of slender build (cf. *Bos longifrons*), No. 24, straddling the vault of the roof, 15 ft. up (see pp. 55 and 59).

# Engraving

# Engraving:

# Inset Painting and

# Tooled Engraving

**T**HE engravings, whether combined or not with paintings, form a group apart, which must be studied separately.

Of direct tracing with the finger on clay not a single instance is to be found at Lascaux, even in the rare places where it might have been possible, as at the bottom of the Shaft. All the engravings were done on the limestone rock in the Passage and never on the calcite. The line, in spite of the sandy character of the wall, is generally very clear. Any retouchings noticeable seem to be towards the end of the stroke, as though the hand had started off firmly and then wavered. The lines were cut with a hard tool, probably a struck flint; in other caves with softer walls, pieces of stalactite were used. The kind of flint tool used cannot be determined, for not one graver or burin has yet been found on or in the cave floor.

In various places in the Apse the engraved lines are associated with scrapings-off of former paintings in black, probably designed to restore the rock to its original colour. The strokes of these scrapings are grouped in parallel lines, and are quite shallow. In several cases, however, the engravings seem to have been inset over old paintings in black intentionally; here the incisions stand out well, showing up the light colour of the rock. The most pleasing example of this effect is given by the two deer, No. 54.

Many of the engravings are combined with paintings. We have already mentioned those of the Nave, and shall not return to them. But at other places in the right-hand galleries, in the Lateral Passage and the Feline Chamber, the head of an ox here and there (e.g. No. 52) is still tinted with red, and a horse here and there with black. Many horses engraved in various parts were probably at first painted in black all over, and still have hooves and chestnuts of intense black, due probably to subsequent retouching. It is possible that nearly all the engravings of the cave were originally painted and that the disappearance of the colours is due to the nature of the rock, which in the course of the millennia has crumbled, leaving nothing

101

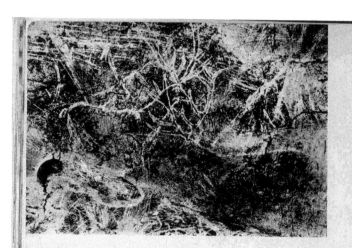

of the original work but the deepest part of the
engraved strokes.

The subjects treated by the engravers are
the same as those of the paintings, but there is
a still greater degree of disorder and inter-
mingling and the impression given is on the
whole rather different; numerous unfinished
pictures of heads, antlers, horns and isolated
hind-quarters give to the Apse and the Lateral
Passage the 'sketch-book' appearance that has
been mentioned above. A remarkable fact,
which confirms this theory for some of the
work, is that these rough sketches are always on
a small scale, measuring on an average from
8 to 16 inches. More sizeable works have gener-
ally been finished, and most of them are exe-
cuted with a complete mastery of the medium.

An inventory of the Lascaux engravings has
yet to be made. It would include several hun-
dreds of items. It seems possible to arrange
them provisionally in three main groups. The
first would contain the large engravings, some

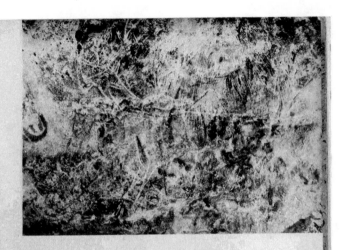

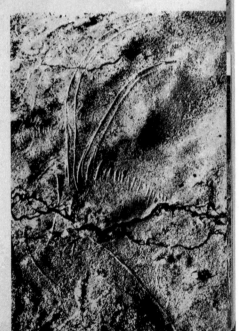

Apse. Engraving of deer (No. 55) on older black paintings, more or less scratched off. Towards the top of the photograph divergent lines in the form of a hut. Length 5 ft. 1 in.

Passage. Heads of ibexes (No. 56 bis) engraved on the sandy rock. Height of each figure 1 ft. 1 in.

complete in themselves, others combined with paintings more or less well-preserved. The pictures in the Nave, many horses and bovidae in the Lateral Passage and Apse and some of the horses in the small space beyond the Feline Chamber might perhaps belong to this group, which differs from the rest only in technique. A second group would include the delicate sketches and miniatures in the Passage and the Apse. Amongst these should be noted, besides the two deer, No. 54, a head of a bison, No. 50, a head of an ibex, No. 51, a head of an ox, No. 52, and a long stem of creeper, or a feather, very finely done. Finally, the pictures in the Feline Chamber and of the small adjoining space form a group which is rather distinct, not so much in their technique or treatment as in the choice of subject and the very large number of emblems represented. This arrangement of a far corner of the sanctuary full of a variety of symbols is not peculiar to Lascaux, but is also found in other Palaeolithic caves.

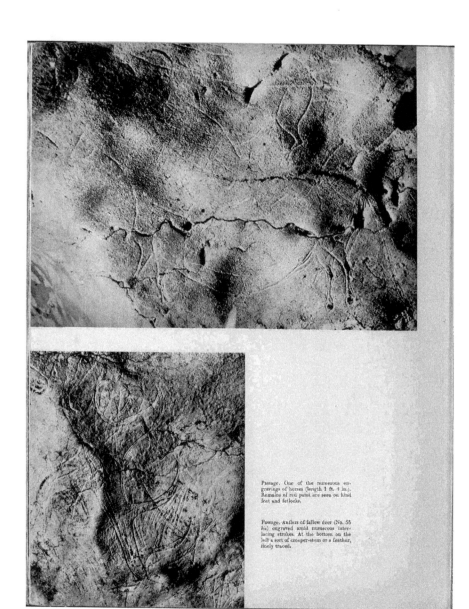

Passage. One of the numerous engravings of horses (length 1 ft. 4 in.). Remains of red paint are seen on hind feet and fetlocks.

Passage. Antlers of fallow deer (No. 55 *bis*) engraved amid numerous interlacing strokes. At the bottom on the left a sort of creeper-stem or a feather, finely traced.

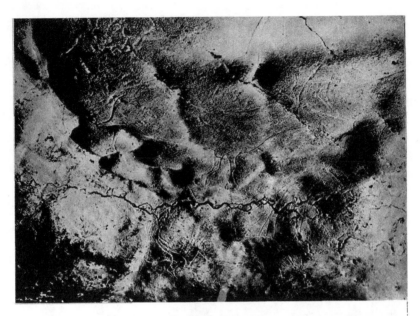

Passage. One of the many engravings of
bovidae intermingled on the wall. Al-
though often incomplete they show a
great regard for exactness.

Passage. To the left below, muzzle and
foot of deer drinking. On the right a
long engraved creeper or feather
(No. 53). Length about 5 ft. 7 in.

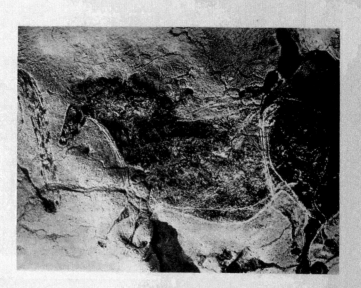

Nave. Horse of Group #1, remarkably painted and engraved. It is enclosed within the crupper of bison No. 62. The engraved line of the belly has certainly been touched up.

Feline Chamber. One of the felines engraved on the wall. Several strokes radiate out from the nostrils. Other traces of drawings are visible, not yet identified.

106

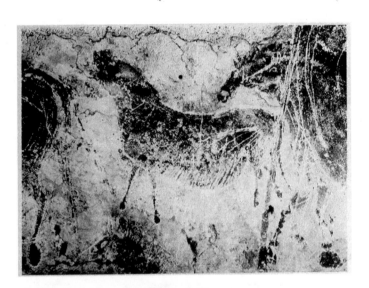

Nave. Detail of horses painted and finely engraved behind the crupper of cow 63 (cf. pp. 86, 87). The hairs on the belly of the middle horse should be noticed.

Apse (No. 53 ter). Example of inter-lacing of engraved strokes on the wall of the Apse. A pair of divergent horns are clearly seen in the middle of the photograph.

107

# The
# Lascaux Fauna

# The Lascaux Fauna:

# Zoological Classification

 HE last glacial epoch, in-
cluding, as it does, the
Upper Palaeolithic, started
after a very long warm
period which perhaps wit-
nessed the emergence of
true *Homo Sapiens*. The
hippopotamus and the
sabre-toothed tiger had
disappeared or migrated to
the south. The *Elephas antiquus* and the
*Rhinoceros merckii* had been replaced by the
mammoth and the woolly *Rhinoceros ticho-
rhinus*, with their very thick coats adapted to a
rigorous climate. In the sheltered valleys, which
alone were habitable, the bear, the hyena and
the felines competed with man for the shelter
of the caves. The reindeer, appearing in Mous-
terian times a little after the mammoth, grew
and multiplied. It lived as far south as the
coast of the Mediterranean, but did not pene-
trate into Italy and was rare in the valleys of
the Pyrenees. Next, the climate, though no
less cold, became drier, and presently the im-
mense ice-cap covering the north of Europe
began to recede. The great glacier of the Alps

and the smaller glaciers of the Pyrenees and
the *Massif Central* of France grow smaller.
Then, towards the end of the Aurignacian
period, the climate tended to become milder.
The steppe gradually gained on the tundra,
and mammoth, reindeer and bison grew rarer.
Herds of wild horses, oxen and bison galloped
over the plains, where a few deer, still un-
common, were also found, along with many
ibexes. The cave bear had almost disappeared,
and was replaced by the brown bear. Felines
and hyenas prowled in search of their
prey.

This phase of warmer climate did not last.
A renewed drop in temperature affected the
whole of Europe, reaching its apex in the
Solutrian period and at the beginning of the
Magdalenian. The tundra regained ground; on
it lived an arctic fauna, dominated by the rein-
deer, the musk ox and the lemming, with an
occasional mammoth. Then there followed
another change of climate, and the arctic fauna
migrated to the north. The steppe covered
Europe once more, and reindeer and mammoth
disappeared. Forests with their fauna made an
appearance somewhat later, and within some

111

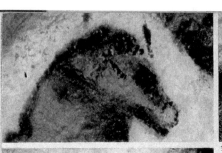

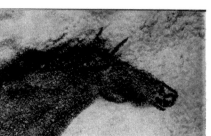

55

28

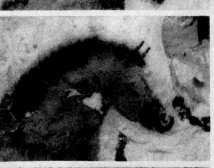

12

ten thousand more years the climate took on more or less its present character.

These variations did not affect the whole of Europe in the same way. The districts close to the edge of the great glacier in the continental climate-zone suffered the full force of the fluctuations. But the regions of the south, on the other hand, and those of the south-west, where all the known caves with paintings and engravings are situated, always remained more temperate. The fauna there doubtless never became completely arctic.

It is almost impossible to date a cave simply by the animals represented in it. The fauna of the end of the Middle Palaeolithic period is not clearly differentiated from that of the Upper Palaeolithic in spite of the enormous space of time separating them. Certain species, it is true, are especially characteristic of one period; the cave-bear is typical of the Mousterian, the horse of the Aurignacian, the reindeer of the early Magdalenian, and the ox and bison of the end of the Magdalenian period. But as all these species are found at all levels, the presence of any of them does not prove a specific date. Only the abundance of one species relatively to others can supply an indication. At Lascaux the inventory of the paintings is relatively easy; but that of the engravings is still unfinished, and months of work would be needed for its

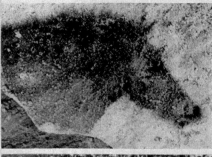

5

58

30

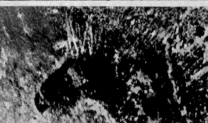

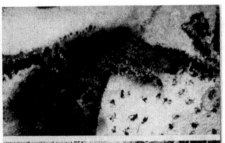

8

completion. The following figures are therefore provisional and only given to show a rough order of magnitude. The species occurring most frequently at Lascaux, as in many other Palaeolithic caves also, are those of the horse tribe. About sixty of them, including two wild asses, are in good condition. There are a great many vestiges of paintings, and especially of engravings, which might perhaps double this figure. The animals of the ox tribe, calculated in the same way, amount to about twenty, without counting the bison. Deer and ibexes are a little less numerous. Then come the bison, to the number of seven, six felines, one rhinoceros, one wolf, one bear, one bird and the 'unicorn'.

The fauna of Lascaux then, with its horses, oxen, bison and deer, is relatively temperate. This is consistent equally with the theory that would put the cave within the Aurignacian phase of warmer climate, or with that which would put it towards the end of the Magdalenian period, in the course of which the bovidae became more and more abundant. The rhinoceros of the Shaft is alone a survival of an earlier glacial epoch. It is a typical steppe fauna, and neither mammoth nor reindeer, except perhaps in one drawing difficult to identify, is reproduced in it. During the warmer phases, they lived much farther

65
bis

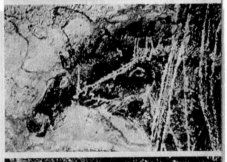

60

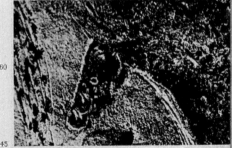

45

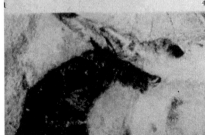

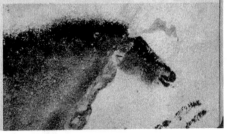

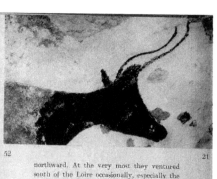

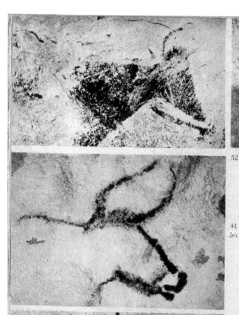

52

21

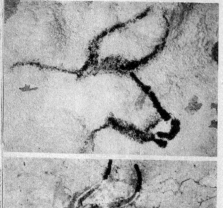

41
bis

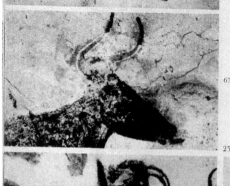

northward. At the very most they ventured
south of the Loire occasionally, especially the
reindeer during its winter migrations, but they
did not constitute the hunters' usual game.

In glacial times the mammoth occurs habitu-
ally with the reindeer, though much less
abundant. They both appeared, almost to-
gether, late in the Mousterian period. They
were to disappear again together at the end of
the Magdalenian; and this can be made to
account, perhaps, for their absence from the
Lascaux fauna. As for *Rhinoceros tichorhinus*
he is equally typical of the cold fauna, but his
zone of distribution is a little more southerly
than that of the reindeer. Moreover, his
being represented at Lascaux may be explained
by the lingering of a few rare members of
the species in the region of the Vézère, despite
the warming of the climate.

The realism of Quaternary art allows in
certain cases not only the genus of its animals
to be distinguished (horse tribe, ox tribe, etc.)
but also the species, races or varieties within
a genus. Distinctions based on the palaeon-
tologists' study of bones, in fact, have in this
way sometimes been confirmed and given pre-
cision. So, too, have details of general appear-
ance, hair, and the like, been attested, which
without these features would have remained
unknown.

63

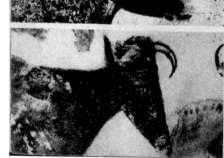

23

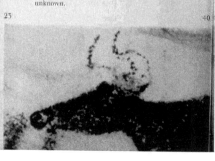

40

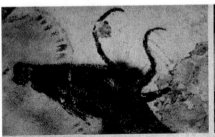

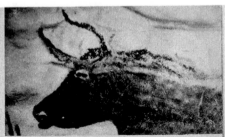

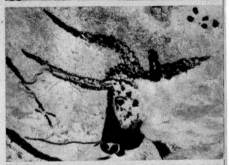

Amongst members of the horse tribe—in addition to the wild ass, No. 27, recognizable by her long ears, small head and slender feet and tail—several types, two at least, are easily distinguishable. One type is small, very short and stocky, with massive head and powerful neck, and resembles the Shetland ponies of today (see, for example, most of the horses in the frieze on page 61), while the other type, larger and elongated, is more akin to the northern or 'Nordic' horse (see, for example, the red and black horse of the plate on page 76). A more careful examination of the paintings shows that several features, such as the shape of the head, the position of the mane and the set of the tail, are common to both these types. And it may indeed be asked whether there really are two distinct types of horse, or whether perhaps the artist was inexact or fanciful. The question has already arisen in regard to Les Combarelles and other decorated caves, where an attempt has been made to distinguish several varieties of equidae and to link them up with known types, either fossil or existing. No solution has seemed really to compel acceptance.

The difficulties that prehistorians have en-countered on this subject perhaps arise partly from the fact that they have tried to determine clearly defined varieties at an exact stage of

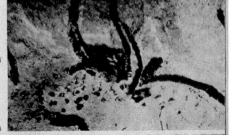

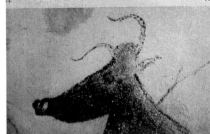

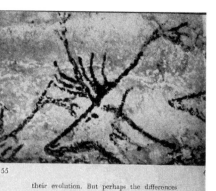

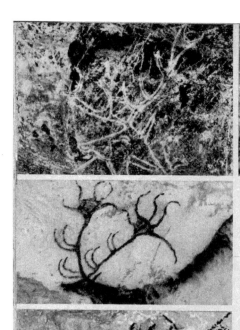

55

46

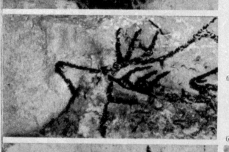

64

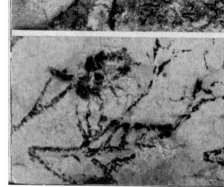

64

their evolution. But perhaps the differences observed in the drawings of equidae correspond to tendencies which were still not yet fixed in determinate types, but were being manifested sporadically, and only destined to attain stability under various influences later on. Modern zoology recognizes in all large mammals three main series of evolutionary tendencies, starting from a type considered as neutral. These tendencies are expressed by variations in the general appearance of the profile and correspond to three sorts of types: the rectilinear, the concavilinear and the convexilinear, each being sub-divided into longilinear, mediolinear and brevilinear.

The three main types are found in the horse tribe of the present day. The convexilinear, differentiated since Neolithic times, has culminated in the Arab horse, delicate and slender, and said to be adapted to life in the desert. The distinctions are less clear-cut between the rectilinear and the concavilinear, especially if we keep to the most primitive types. A firm and heavy stock corresponds to the horses of the Solutré charnel-bed (page 56), and perhaps

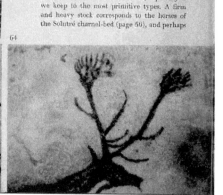

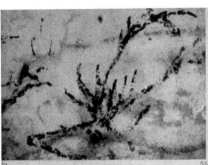

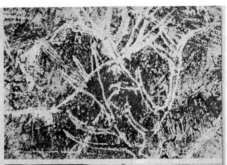

54

54

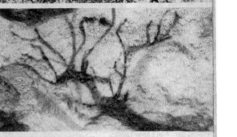

leads in a direct line up to the Camargue horse
of modern France. Parallel to this line of steppe
horses runs another, smaller, more thick-set
and better adapted to the forest. It comprises,
with domestic representatives like the Shetland
pony, the only wild types of horse now extant.

11

The wild horse survived for a long time in
our regions early in historic times. Varro,
Strabo and Herodotus speak of the wild horses
of Spain, of the Alps and of the Danube. In the
tenth and eleventh centuries these horses
were still considered choice game in Switzer-
land. Apparently they did not disappear from
the Vosges until the seventeenth century, nor
from Lithuania until a century later. At the
present day the horse still exists in a wild state
in the deserts of Gobi and the Altai, where it
was only rediscovered in the nineteenth cen-
tury; it is called the Przewalski horse. With its
very large head, long drooping ears, and short
straight mane (not found in any domesticated
breed) it certainly represents an ancient type.
And it is strangely like some of the rock
paintings and engravings; in particular the
little ponies of the frieze on page 61.

11

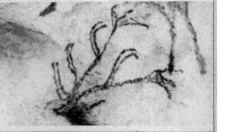

54

56

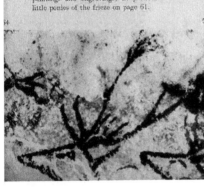

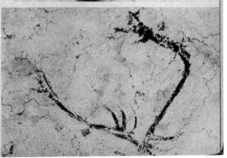

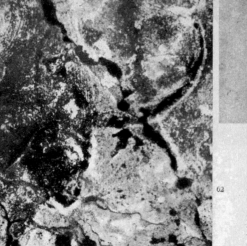

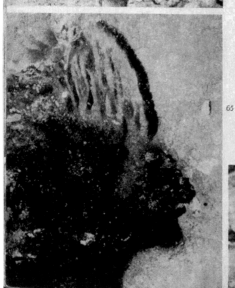

Furthermore, and this is the main thing, in a family of Przewalski horses lately studied in captivity, it has been established that the three tendencies of the rectilinear, concavilinear and convexilinear were displayed among descendants of the same parents. Such lack of differentiation never occurs in the domestic breeds. The Przewalski horse appears to be the present-day representative, scarcely modified at all, of the immense herds of wild horses which frequented the steppes of Europe during the whole Quaternary period. Migrations caused by variations of climate together with much cross-breeding perhaps impeded the fixing of characters in determinate types. This fixing was no doubt effected later, either under the influence of domestication and its concomitant selection, or also as a result of the isolation of herds in special areas, delimited usually by the presence of man. Its tentative beginnings in Palaeolithic times are shown by the presence among the Lascaux horses of the two types above mentioned, their characters, however, being still liable to intermingling.

The identification of members of the ox tribe is not nearly such a complicated matter. The walls of Lascaux show two very distinct types of *Bos*. The first, represented in the Main Chamber and its Axial Passage, is the *Bos primigenius* (Nos. 9, 13, 15, 18 and 26), easily

62

62

65

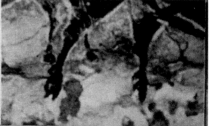

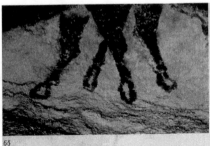

65

52
bis

recognizable by its enormous size (six foot six to the withers), and its very long horns, curved and turning slightly to the side. This ox appeared at the beginning of the Quaternary epoch, but only became abundant at the end of the Magdalenian. The sporting bulls of Spain and the black half-wild bulls of the Camargue are said to be its direct descendants. And indeed the likeness between the great black bull, No. 26, and the bulls of the Camargue, is striking. Wild bulls were abundant in Europe in historic times and only disappeared from France in the thirteenth century and from Lithuania in the eighteenth.

The other type of ox represented at Lascaux is more slender in form and its horns are shorter and horizontal. Its whole silhouette, the lines of back and muzzle are surprisingly rectilinear. It suggests the *Bos longifrons*, of whose early history little is known. It is represented by examples Nos. 21, 23, 24 and 44 of the Axial Passage and doubtless also by the enormous cow in the Nave, No. 63.

The deer depicted at Lascaux appear all to be red deer, perhaps of the kind which still frequents our forests. Could deer No. 46, with his gigantic antlers, be the 'great elk' *Megaceros euryceros*? It is hardly likely; for though his antlers are immense, yet they are not palmate, like those of the fallow deer and elk. The end

65

62

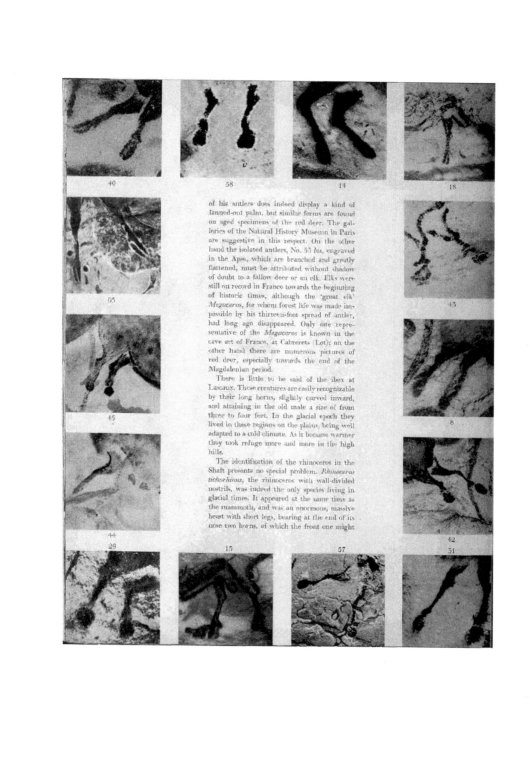

of his antlers does indeed display a kind of fanned-out palm, but similar forms are found on aged specimens of the red deer. The galleries of the Natural History Museum in Paris are suggestive in this respect. On the other hand the isolated antlers, No. 55 *bis*, engraved in the Apse, which are branched and greatly flattened, must be attributed without shadow of doubt to a fallow deer or an elk. Elks were still on record in France towards the beginning of historic times, although the 'great elk' *Megaceros*, for whom forest life was made impossible by his thirteen-foot spread of antler, had long ago disappeared. Only one representative of the *Megaceros* is known in the cave art of France, at Cabrerets (Lot); on the other hand there are numerous pictures of red deer, especially towards the end of the Magdalenian period.

There is little to be said of the ibex at Lascaux. These creatures are easily recognizable by their long horns, slightly curved inward, and attaining in the old male a size of from three to four feet. In the glacial epoch they lived in these regions on the plains, being well adapted to a cold climate. As it became warmer they took refuge more and more in the high hills.

The identification of the rhinoceros in the Shaft presents no special problem. *Rhinoceros tichorhinus*, the rhinoceros with wall-divided nostrils, was indeed the only species living in glacial times. It appeared at the same time as the mammoth, and was an enormous, massive beast with short legs, bearing at the end of its nose two horns, of which the front one might

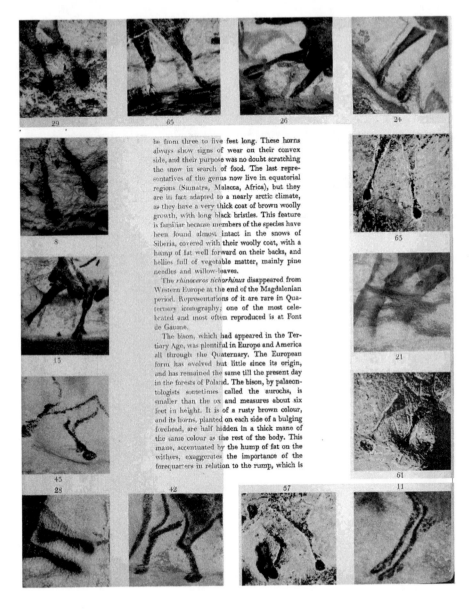

be from three to five feet long. These horns always show signs of wear on their convex side, and their purpose was no doubt scratching the snow in search of food. The last representatives of the genus now live in equatorial regions (Sumatra, Malacca, Africa), but they are in fact adapted to a nearly arctic climate, as they have a very thick coat of brown woolly growth, with long black bristles. This feature is familiar because members of the species have been found almost intact in the snows of Siberia, covered with their woolly coat, with a hump of fat well forward on their backs, and bellies full of vegetable matter, mainly pine needles and willow-leaves.

The *rhinoceros tichorhinus* disappeared from Western Europe at the end of the Magdalenian period. Representations of it are rare in Quaternary iconography; one of the most celebrated and most often reproduced is at Font de Gaume.

The bison, which had appeared in the Tertiary Age, was plentiful in Europe and America all through the Quaternary. The European form has evolved but little since its origin, and has remained the same till the present day in the forests of Poland. The bison, by palaeontologists sometimes called the aurochs, is smaller than the ox and measures about six feet in height. It is of a rusty brown colour, and its horns, planted on each side of a bulging forehead, are half hidden in a thick mane of the same colour as the rest of the body. This mane, accentuated by the hump of fat on the withers, exaggerates the importance of the forequarters in relation to the rump, which is

slender and drooping, and gives a special silhouette to the bison, easily recognizable in the numerous Quaternary pictures of it. The two back-to-back bisons, No. 65, and the bison pierced by arrows, No. 62, show this characteristic outline. Their long horns, however, clearly separate from the mane, are less typical than the little splayed horns of bison No. 52 *bis*.

In the Feline Chamber the Abbé Breuil has discerned five or six animals which are peculiar in their short round muzzles, their little raised ears and the line of their backs. It is difficult to tell what this species of feline can be. There is nothing exactly to compare with it. At all events it cannot be the sabre-toothed tiger (*Machaerodus*), which disappeared towards the beginning of human times. It is unlikely to be a lynx or wild cat, of which an occasional specimen, still lingering on, is sometimes killed in France. The felines depicted in Quaternary art are without doubt large 'cave-cats', otherwise called 'cave-lions'. Not much is known about this species but it is usually associated with a cold fauna. The few known representations, the best being perhaps at Les Combarelles, give little in the way of precise data. Is it a tiger or a lion? It is striped; but striped coats are found in many primitive species, so that this proves nothing.

Nearly all known representations of the Quaternary bear indicate the brown bear rather than the cave-bear. The cave-bear (*Ursus spelaeus*), indeed, being the victim of physiological defects, was already rare in the Aurignacian period, and towards the end of the Solutrian period it became extinct. The brown bear was at that time in process of development, and in Magdalenian times it was the only member of its species in Europe. The little bear at Lascaux, raising its muzzle under the belly of bull No. 15, is a brown bear, identified as such not by its size, a weak criterion in any case, but because of the almost convex shape of its forehead, very clearly visible on the figure on page 79. The cave bear on the other hand has a particularly bulging forehead.

Of the bird we shall say nothing. It is so schematically portrayed that its species really cannot be identified. Perched on its stake, more symbolic than real, it seems to belong rather to the realm of rite and superstition, than to the living fauna which we have now reviewed.

# The Cave Art of Prehistoric Western Europe

# The Cave Art of

# Prehistoric Western Europe:

# The Evolution of Styles

HE eighteenth century imagined man our ancestor as a 'noble savage, who ate his fill beneath the oak, quenched his thirst from the nearest stream, and lay down to sleep at the foot of the same tree that had given him his meal'.

The nineteenth, with its infant science of prehistory, replaced him by the picture of a being who was almost bestial, armed with flints or sharpened sticks, dressed in animal skins, wallowing in subterranean dens, and certainly incapable of any religious or artistic consciousness. When, in 1857, engravings of hinds on bone were discovered in France at Chaffaud, no one thought of assigning to them a high antiquity. Only some thirty years later, when the discoveries of Lartet at La Madeleine and the excavations of Piette came in 1864, was it realized that the men of the Reindeer Age were already capable of artistic creation. For a long time after that, however, nothing was known of the art but carvings on bone, wood and ivory, of which there

are extant today a great many examples.

In 1879 a Spanish archaeologist, Don Marcelino de Sautuola, while exploring in the province of Santander a cave which had been discovered a few years earlier, saw in it magnificent mural paintings. He made a report immediately, but this passed unnoticed, and, outside a few exceptional specialists, no one believed that the paintings were really ancient. Yet what Marcelino de Sautuola had discovered was the first and the most marvellous of Palaeolithic caves, the cave of Altamira.

In 1889, in France, L. Chiron described the cave of Chabot, which he had discovered ten years before in the Ardèche; but he succeeded no better in arousing the interest of the scientific world. Years passed; Altamira and Chabot had been forgotten; but then, in 1895, Émile Rivière drew the attention of the French Academy of Sciences to the engraved drawings decorating the walls of the cave of La Mouthe, in the Dordogne. He attributed them to the Palaeolithic period. In the following year the cave of Pair-non-Pair was discovered in the Gironde; in 1897, that of Marsoulas in the Haute-Garonne, though the drawings in it

125

were only barely seen; and then, in 1901, the cave of Les Combarelles in the Dordogne. The antiquity of these works of cave-wall art was after that unchallenged, and discoveries multiplied both in France and Spain.

At first they were more numerous in France, and, in turn there were discovered Font de Gaume (Dordogne), then Marsoulas (which till 1902 had been scarcely at all explored), the Mas d'Azil (Ariège) and Bernifal and Teyjat (Dordogne) in 1905, Gargas (Hautes-Pyrénées) and Niaux (Ariège) in 1906, and so on progressively.

In Spain the study of the Altamira cave began in 1902, with the visit of Cartailhac and Breuil, and it was carried on by Alcalde del Río, who undertook a systematic exploration of the caves in the Cantabrian region. In 1905 he discovered the paintings of Covalanas and La Haza, the engravings of Hornos de la Peña, and then the cave of Castillo, the most important of the whole group after Altamira. In 1904 Father Sierra found the engravings in the cave of La Venta, and in the same year Alcalde del Río and Breuil explored a curious cave with engravings on clay, which they called La Clotilde. Several other caves of less importance were discovered in the following years; then came Pindal, in 1908, and then Quintanal, Mazaculos, and others.

Also, in Eastern Spain, there was discovered a whole series of painted rocks and rock-shelters —Calapata, Cogul, Alpera, Cretas, and more besides—which in some of their characters are related to the Palaeolithic art of France and the Cantabrian Mountains, but in others are quite distinct from it. These rock-paintings, too, show an abundant fauna; it differs from that of more northerly regions because of different conditions of climate, but also, with it, are many representations of human beings. Scenes are depicted of the hunt and of war, attesting the use of the bow, and at Cogul even dances. It has been thought that the oldest of these paintings may date perhaps from the Aurignacian period. French scholars at least have seldom felt able to doubt that the whole series is Palaeolithic. But this East Spanish art developed independently from the Franco-Canta-

126

brian, and must be studied separately. The same may be said of the rock-painting of Western and Southern Spain (Laban Jimena, Fuencaliente, Batuecas, etc.), in which schematized art-forms are much more developed. The question of relations between the art of Eastern Spain and that of the rock-painting of North Africa has often been raised; but the nature of the relationship seems still uncertain.

The list of discoveries made in Cantabrian Spain and in France would be too long for insertion in this chapter. A complete inventory has not been made, but it would without doubt reach the hundred mark. The most important caves are shown on the map on page 126. Their area of distribution, appearing strictly limited at first to Spain and Southern France, has been considerably increased by the discovery in the Terra d'Otranto (the 'heel' of Italy) of several rough engravings on the walls of the Grotta Romanelli. Although very rudimentary these engravings nevertheless belong to the French and Spanish group. This example, still unique in Italy, makes one hope for more discoveries. Explorations were indeed carried on in France all through the late war. In addition to the Lascaux discovery, made in 1940 and by far the most sensational, the following are the most important: La Baume-Latrone (Gard) and the cave of Peyrort (Ariège), in 1940; the cave of Hurioko-Harria (Basses-Pyrénées), in 1945; the cave of Ebbou (Ardèche) and the cave of The Horse (Yonne) in 1946. This latter extends the boundary of the distribution of known decorated caves much farther to the north.

The study of a map of these caves shows that geographically they are distributed in clearly localized groups. The most important covers the whole chain of the Pyrenees and the Cantabrian Mountains. The principal caves of this group, on the Spanish side, lie around Altamira in the province of Santander; La Venta de la Perra and La Sottariza, La Haza, Covalanas and Salitre in the defile of Carranza in the region of Ramales, then Hornos de la Peña, Castillo, La Pasiega, and farther to the west Pindal, Mazaculos and Quintanal. On the French side there must be mentioned Gargas in the Hautes-Pyrénées, Marsoulas in the

Haute-Garonne, and Niaux, the Maz d'Azil, Le Portel, the Tuc d'Audoubert, Les Trois Frères and Bedeilhac, all in the Ariège.

The Dordogne or Périgord group, in which may be included Pair-non-Pair, Teyjat and the caves of the Lot, is less extensive, but very dense, and contains a number of masterpieces, the most important lying within a radius of twelve miles from Les Eyzies. In addition to the caves already mentioned La Calevie and Bernifal should especially be noted. This Périgord group and that of the Pyrenees are closely related; but the departments of Gard and Ardèche, which are much less important, form a group of their own, with the caves of Ebbou, Le Figuier and Chabot, occupying a distinct region under Mediterranean influence. The Cave of The Horse at Arcy-sur-Cure (Yonne) shows Aurignacian technique, but so far is quite isolated.

All this art, whether in the Pyrenees, in the Périgord, or towards Provence, shows a great degree of unity. It can be considered as a whole, and reconstruction of its development, mode of propagation, and so on, can accordingly be attempted. From 1912 onwards the Abbé Breuil, who had then already devoted years to the study and analysis of Quaternary art, has been engaged in an attempt to trace the main stages of this development, always considering his own work, however, not as a finishing-point but as a starting-point for fresh hypotheses.

Very briefly summarized, the conclusions arrived at by the Abbé Breuil are these. The art of painting and engraving on rock-walls, he believes, was initiated at the beginning of Upper Palaeolithic times in south-west France and north-west Spain. For a very long period, during which climatic conditions, fauna, vegetation, and perhaps also human populations, altered several times, it went on evolving here, without any perceptible introduction of art from elsewhere. From the opening of the Aurignacian to the end of the Magdalenian period the changes from stage to stage were progressive and did not affect the nature of the art, which always depicted animals, and remained realist, except in its extreme phases—

its beginning and its period of decadence. Towards the end of Magdalenian times tribes from Italy and Spain invaded North-West Europe. They brought with them a schematic and geometric art which perhaps originated in the south and west of Spain. Its influence had indeed already been felt sporadically on the Magdalenian art of the Cantabrian and Pyrenean regions. But this diffusive influence was doubtless followed by a direct one, proceeding from the 'Capsian' people of south Spain, who, upon the arrival of 'Neolithic' people in their country, will have been thrust back towards the north. At that, Magdalenian art quickly disappeared, being replaced by the new geometric art, of which nothing much remains in France but the 'Azilian' painted pebbles of this age found at the Mas d'Azil.

The discoveries of more recent years may not have contradicted all these theories, but they have not left them confirmed in any definite way. They have, indeed, often complicated the issue. The Abbé Breuil has shown—and he remains the unchallenged specialist on the material—that the development of Franco-Cantabrian art can no longer be thought to have run in one single line. Now and in future, two great successive cycles have to be distinguished in it: the Aurignacian cycle and the Magdalenian cycle. But the transition from one to the other remains obscure; and between them comes Solutrian art, the distribution and influence of which are still little known. It is represented especially by the remarkable sculptured friezes of the Charente. The analytical study of these cycles was first expounded by the Abbé Breuil at the French Prehistoric Congress held at Périgueux in 1934.

Aurignacian art starts with painted representations of human hands and feet. The hands are at first 'negatives', done apparently by stencil; later they become 'positives', made almost certainly by soaking the hand in paint and applying it directly to the wall. This mode of application is still used among certain primitive peoples of Asia and Africa. At the same time there are to be seen the first attempts at representations of animals, first done in very rudimentary yellow or red strokes, and

127

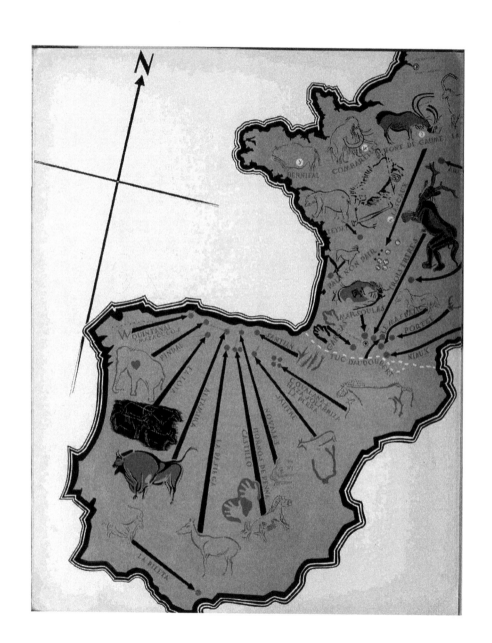

# ART PARIETAL
## FRANCO CANTABRIQUE

SERGEAC

CORE

CABRERETS

EBBOU

CHABOT

ROMANELLI

Map drawn by Jannszéski

120

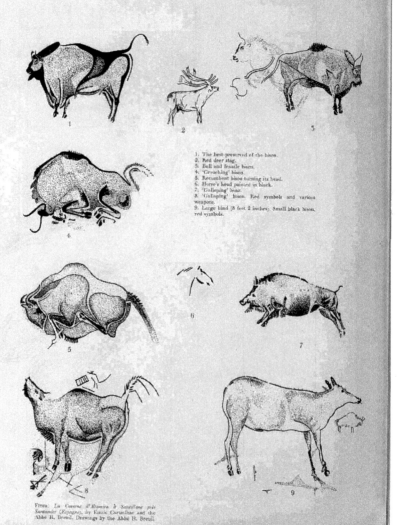

1. The best-preserved of the bison.
2. Red deer stag.
3. Bull and female bison.
4. 'Crouching' bison.
5. Recumbent bison turning its head.
6. Horse's head painted in black.
7. 'Galloping' boar.
8. 'Galloping' bison. Red symbols and various weapons.
9. Large hind (8 feet 2 inches); Small black bison, red symbols.

From: *La Caverne d'Altamira à Santillane près Santander (Espagne)*, by Émile Cartailhac and the Abbé H. Breuil. Drawings by the Abbé H. Breuil.

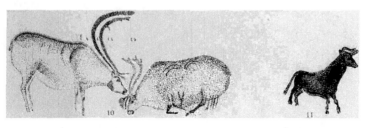

10. Two large reindeer in polychrome, facing each
other.
11. Bull, painted in flat black.
12. *Rhinoceros tichorhinus*, painted in red outline.
13. Bison in polychrome.
14. Black horse in shaded relief.
15. Wolf in polychrome.
16. Small bison in polychrome.
17. Small engraved mammoth and red tectiform
symbol.
18. Bull, painted in flat black.

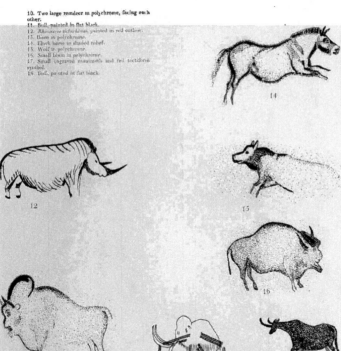

From. *Font de Gaume aux Eyzies*, by Dr L. Capitan,
the Abbé H. Breuil and D Peyrony. Drawings by
the Abbé H. Breuil.

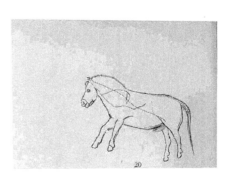

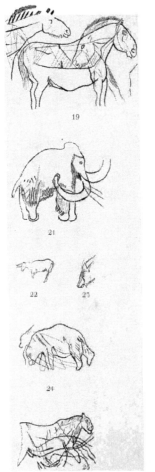

19.

21.

22.    23.

24.

20.

19. Horse, big and heavily-built, other horses' heads.
20. Horse, with short, straight back, thin tail, and thick legs.
21. Fine mammoth, with trunk bent back.
22. *Bos primigenius*, of very slender build.
23. Wolf's head.
24. Fine cave-bear, walking.
25. Maneless lion.
26. Large horse, with long, thin head, big eye and very short back.
27. Hind's head, painted in black.
28. Ibex.

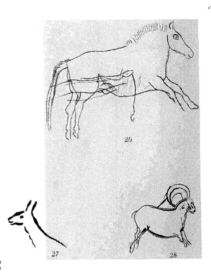

26.

27.    28.

From: *Les Combarelles aux Eyzies*, by L. Capitan, the
Abbé H. Breuil and D. Peyrony. Drawings by the
Abbé Breuil.

152

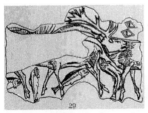

30

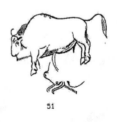

31

29. LORTET (Hautes-Pyrénées). Stags and salmon, engraved.
30. LE BOUT DU MONDE (Les Eyzies, Dordogne). Hind with her fawn (engraving on limestone)
31. FONT DE GAUME (Dordogne). Very large engraving of bison (on Bruniquel schist)
32. TEYJAT (Dordogne). Galloping horse.
33. GOURDAN (Haute-Garonne). Heads of chamois, and one perhaps of marmot (engraving on reindeer-antler).
34. SAINT-MARCEL (Indre). Running reindeer engraved on schist.
35. LAUGERIE-BASSE (Dordogne). Engraved reindeer.
36. ISTURITZ (Basses-Pyrénées). Hare (engraving on stone).
37. LIMEUIL (Dordogne). Grazing reindeer (engraving on stone).
38. LAUGERIE-BASSE (Dordogne). Woman with reindeer (engraving on reindeer-antler).
39. ISTURITZ (Basses-Pyrénées). Wounded bull.
40. LIMEUIL (Dordogne). Horse.
41. LA MADELEINE (Dordogne). Mammoth (engraving on flat piece of ivory).
42. LAUGERIE-BASSE (Dordogne). Horse.

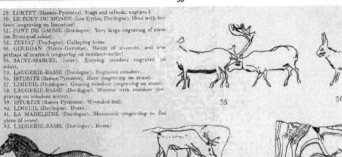

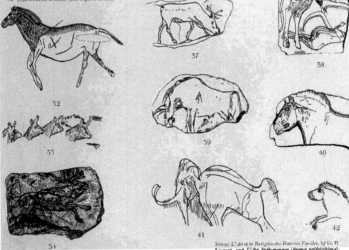

From: L'Art et la Religion des Hommes Fossiles, by G. H. Luquet, and L'Art Préhistorique (époque paléolithique), by René de Saint-Périer.

153

43. BERNIFAL (Dordogne). 44 LES COMBARELLES (Dordogne). Tectiform symbols and schematised stag 45 FONT DE GAUME (Dordogne). Engraving possibly representing a hart. 46. NOVALES (Spain). Various symbols. 47. ALTAMIRA (Spain). Radiating figure, on the great roof, possibly representing a hut. 48 FONT DE GAUME (Dordogne) Tectiform painted beneath the large reindeer 49. CASTILLO (Spain). Tectiform painted in red. 50. LA PILETA (Spain). The principal tectiform symbols, painted in black. 51 ALTAMIRA (Spain). Group of various tectiform symbols painted in black. 52. FONT DE GAUME (Dordogne) Tectiforms engraved on the left side of the Rubicon ante-chamber 53. ALTAMIRA (Spain) Modified form of tectiform symbol and other unintelligible figures forming a group painted in black. 54 CASTILLO (Spain). Tectiform, somewhat analogous to those in the French caves, drawn in red 55. LES TROIS FRÈRES (Ariège). Man disguised as a bison, preceded by a fantastic female animal, with the hindquarters of a reindeer and the forequarters of a bison, and by a female reindeer with forelegs resembling human arms or duck's legs. 56. ISTURITZ (basses-Pyrénées), and 57. ALTAMIRA (Spain). Engravings apparently representing human beings. 58. LES COMBARELLES (Dordogne). Flat pebble of Lourdes schist, with engraving of bearded man with head crowned with feathers or horns and false tail. 59. LES COMBARELLES (Dordogne). Figure of human shape. 60 CABREREIS (Lot) Man apparently drawing a bow. 61. ABRI MÈGE (Dordogne) So-called 'imps', really representations of masked figures (or of spirits) engraved on a perforated staff. 62. LES TROIS FRÈRES (Ariège). The Sorcerer (wall painting) 63. CASTILLO (Spain). Hands outlined by red paint. 64. LES TROIS FRÈRES (Ariège). Figure of human shape. 65. LES COMBARELLES (Dordogne). Masked figures

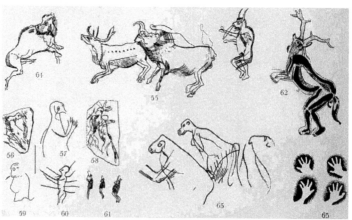

154

then in broad bands or in wide plaques of colour, which again is red. A few silhouettes are rendered by means of dots.

After that come figures done in thin line, first yellow, then red; later, those in thick or 'pasty' line. Along with these linear drawings occur a great many tectiforms, of geometric shape, which are numerous both in France and Spain. Then in succession come paintings in flat colour, at first incomplete, red or black and with similar tectiforms occurring with them; black outlines on a red background; and finally paintings in black outline of a more developed type.

Engraving seems to have appeared at the same time as painting. It starts with finger tracings on soft clay, and goes on with incisions in stone; it is very clumsy at first, and disregards detail altogether, but it becomes more finished and more deeply done, and approaches even sometimes to low relief work.

A criterion—in so far as such a thing is possible in a field like this—which would distinguish Aurignacian art from the ensuing Magdalenian, is twisted perspective, which is nearly always used, especially for the antlers of the deer. Aurignacian cave art covers more or less all the distribution-area of the Franco-Cantabrian art of Palaeolithic times in general, but it is relatively more prominent in the Mediterranean regions. And it seems to lie at the roots of the distinctive art of Eastern Spain.

The Magdalenian cycle does not start with such rudimentary designs as the first Aurignacian tracings. Its first phase is characterized by a universal use of black; the linear renderings of animals and tectiforms develop from a fine-line treatment to a thicker and more pasty line, and presently to all-over painting, first in flat black colour, and finally in modelled or plastic style. Next, black is succeeded by brown. Then appear the first figures done in polychrome. They develop, and reach perfection in the marvellous works at Altamira, and those of the Font de Gaume, which belong to the sixth Magdalenian phase. From that climax, the spectacle becomes one of abrupt decadence, the figures become schematized,

and there is an abundance of signs and symbols. In the cave of Marsoulas, the latest tracings are clearly Azilian work.

The development of engraving in the Magdalenian, even more than that of painting, is an affair of theory. The only reliable attributions are of engravings filled with parallel hatching to the third Magdalenian phase, and of sculptured blocks, very like the Solutrian reliefs, to the third or fourth. Apart from its great artistic power, Magdalenian work is distinguished by delicacy of detail and by the absolute rendering of profile. The antlers of stags are always shown in profile, and where a second antler is given it is lined in behind the first. Magdalenian art is found in two main centres; the Dordogne, and the region of the Pyrenees and Cantabrian Mountains.

The broad lines of development which we have just summarized were laid down several years before the discovery of Lascaux. Comparison is therefore particularly interesting between them and the Lascaux sequences, with a view to finding how far they agree or disagree. Such comparison is distinctly difficult, because schema is always much less flexible than reality, and a cave has seldom been occupied throughout all the phases of the development. Inferences drawn from these comparisons contain much that is arbitrary, and a good deal also that is intuitive; and they cannot yet be worked out with mathematical rigour.

If the relative chronology of the Lascaux works be compared with the phases of the Abbé Breuil's Aurignacian and Magdalenian cycles, a disconcerting fact emerges. The Lascaux sequence will fit into the Magdalenian cycle as easily as into the Aurignacian. On the theory of an Aurignacian age for Lascaux, the earliest phases of the cycle are missing, or are only indicated by unrecognizable traces, and most of the pictures will occupy a position beginning with the 'paintings in flat colour, at first incomplete' mentioned above: that is, with Nos. 52, 53, and 54. But these are much more varied than our previous knowledge of the Aurignacian cycle would allow us to expect. In what phase, for example, are we to place the

horses with smoky manes, or those excellent oxen in uniform flat black, and many others besides?

Lascaux has been held to be Aurignacian on account, above all, of its twisted perspective. But is this criterion as rigid as it is usually considered? As we have seen above, the perspective of the horns of bovidae at Lascaux is far from being typically twisted. It varies very much from one work to another, even within a homogeneous group, as for instance the group on the roof of the Axial Passage. In certain cases it curiously resembles the perspectives used by Magdalenian artists, in their engravings on ivory. Moreover, thrown-back antlers of deer, as in frieze No. 64, occur frequently in Magdalenian art. Finally, it should be noted that the twisted perspective of the hooves of bovidae, which at Lascaux is very striking, was used also by the men who did the most highly-developed of all Magdalenian work, at Font de Gaume and Altamira.

To these facts we can add, on the one hand, what data are furnished by the tools (page 45), and on the other by the fauna (page 109). The upshot remains this. the question of the age of Lascaux remains a question. It is still not definitely settled. Future studies perhaps may come to supplement the Aurignacian cycle by phases hitherto unknown. Or they may clear up—this possibility is by no means out of the question—the relations between this cycle and the Magdalenian, which are still obscure. Or equally, they may extend our knowledge of Magdalenian art.

The fact is that none of these things is very clear. What is needed, now that material is more abundant, is a fresh classification of the art on portable objects; for that alone, or almost alone, can be reliably dated by stratified associations. With this classification, taken as a basis, one could then compare, and perhaps modify accordingly, the sequence-dating of the art on cave-walls. One might then find certain problems solved. A comparative study of the fauna, that portrayed in each of these arts and that represented by the bones in stratified deposits, would be another good thing to undertake.

Yet whatever the results that can be hoped for, and however ingenious the theories that may be devised on the origin and development of the art, one fact will remain unchallenged and unchallengeable; the marvellous artistic mastery of our very distant ancestors.

# Table of the Quaternary Period for Western Europe

(Modified from Boule, 'Les Hommes Fossiles', for this edition)

| GEOLOGY | | | ZOOLOGY | MAN | ARCHAEOLOGY | | |
|---|---|---|---|---|---|---|---|
| HOLOCENE or RECENT | | POST- -GLACIAL | Domestic Breeds | HOMO SAPIENS | 1000 2000 3000 B.C. BRONZE AND IRON AGES — NEOLITHIC | | |
| | | | FOREST FAUNA | | MESOLITHIC | | |
| PLEISTOCENE | UPPER | WÜRM GLACIATION ('Last') | SUB-ARCTIC, STEPPE AND TUNDRA FAUNAS including Elephas primigenius (mammoth) Rhinoceros tichorhinus Equus caballus and przewalskii (horses) Rangifer tarandus (reindeer) Cervus elaphus (red deer) Bos primigenius Bison priscus etc. | HOMO SAPIENS FOSSILIS, CRO-MAGNON, GRIMALDI, CHANCELADE &c. | MAGDAL- -ENIAN SOLUTRIAN AURIGN- (PERI- -ACIAN -GORD- -IAN) | UPPER | PALAEOLITHIC |
| | | 'Last' Interglacial | Elephas primigenius (mammoth) Elephas antiquus Rhinoceros merckii Equus caballus Megaceros giganteus Bos primigenius Bison priscus etc. | HOMO NEANDERHALENSIS | MOUSTERIAN &c. | MIDDLE | |
| | MIDDLE | RISS GLACIATION ('Penultimate') | Elephas trogontherii etc. | SWANSCOMBE | CLACTONIAN — TAYACIAN — LEVALLOISIAN — ACHEULIAN | LOWER | |
| | | 'Great' Interglacial | Elephas antiquus Rhinoceros merckii Equus of caballus etc. | | | | |
| | LOWER | MINDEL GLACIATION ('Antepenultimate') | Elephas trogontherii etc. | HEIDELBERG | ABBEVILLIAN (or 'CHELLIAN') | | |
| | | 'First' Interglacial | Elephas meridionalis Rhinoceros etruscus Equus stenonis etc. | | About 500,000 B.C. | | |
| | | GÜNZ GLACIATION ('Early') | Elephas meridionalis etc. | | ? ? | | |

# Bibliography

No study of the complete cave of Lascaux has appeared since the report made by the Abbé H. Breuil to the French Academy of Inscriptions and Belles Lettres in 1941. This report was published in Spanish to the 'Atlantis', or Actas y Memorias de la Sociedad Española de Antropologia etnografia prehistoria, in 1941, Volume XVI, parts 3 and 5, and in French in the Supplement to the Bulletin of the Historical and Archaeological Society of the Périgord in 1940.

## GENERAL BOOKS ON QUATERNARY ART
### FRENCH

G. H. Luquet. *L'art et la religion des hommes fossiles.* Paris, 1926.

R. de Saint-Périer. *L'art préhistorique.* Paris, 1932.

H. Breuil. *L'évolution de l'art pariétal dans les cavernes et abris ornés de France,* in Congrès préhistorique de France, Périgueux, 1934.

L. Capitan, H. Breuil and D. Peyrony. *La caverne de Font de Gaume.* Monaco, 1910. *Les Combarelles.* Paris, 1924. Both in the fine series 'Archives de l'Institut de Paléontologie Humaine', in which similar monographs have appeared also on most of the Spanish caves, *Altamira, La Pasiega, La Pileta, Les Cavernes des Monts Cantabriques,* etc., all largely the work of Breuil.

E. Bourdelle. *Essai d'une étude morphologique des équidés préhistoriques de France d'après les gravures rupestres,* in 'Mammalia', Vol. II, No. 1, March 1938.

Salomon Reinach. *Répertoire de l'art quaternaire.* Paris, 1913.

A. Thevenin. *La faune disparue de France.* Paris (Payot), 1945.

Kurt Lindner. *La chasse préhistorique.* Paris (Payot), 1941.

L. Franchet. *Les couleurs aux temps préhistoriques.* Institut International d'Anthropologie, Congrès de Toulouse, 1924, p. 381.

G. H. Luquet. *Le réalisme dans l'art paléolithique.* 'L'Anthropologie', Vol. XXXIII, 1923, pp. 17–48.

### ENGLISH

G. Baldwin Brown. *The Art of the Cave Dweller.* London· John Murray, 1928.

M. C. Burkitt. Chapters X–XIII of *The Old Stone Age,* Cambridge, 1933; and for comparison, the same author's *Prehistory,* 2nd edition, Cambridge, 1925.

*Acknowledgment*

I wish to express to Mlle Annette Laming, research assistant at the C.N.R.S., my deep gratitude for the valuable assistance she afforded me in the achieving of this work and for the thorough study of sources and references which she carried out for the purpose.

Continued from front flap]

craft, can be counted faithful and well done. Infra-red photography, too, used here on a Palaeolithic subject for the first time, has been applied to details with real success.

'Over and above all this, Monsieur Windels has written the original text of the book himself; and he has had the expert help of Mlle Annette Laming, who holds a research fellowship, as we should call it, at the National Scientific Research Centre in Paris. Having taken part in its translation into English, I know what I am doing when I praise it. It might have been made an academic thesis, "proving" this and that about age or attribution, and no more: actually, it is a spontaneous introductory essay, in which scholarship is a background, learning serves not to close questions but to open them, and language is used neither for controversy nor for rhapsody, but— and this goes for Monsieur Leroi-Gourhan's fine Introduction also—simply to quicken and guide appreciation.'

★

## Arrest and Movement

An Essay on Space and Time in the Representational Art of the Ancient Near East

by

H. A. GROENEWEGEN-FRANKFORT

*With 96 pages of illustrations from photographs and many line drawings in the text*      50s. net

∴

## Classical African Sculpture

by

MARGARET TROWELL

*With 48 pages of illustrations from photographs*
30s. net

Please write to Faber and Faber, 24 Russell Square, London, WC1, for a list of Books on the Arts.

CPSIA information can be obtained
at www.ICGtesting.com
Printed in the USA
BVHW052317090223
658265BV00003B/78